IMAGES
of America

AFRICAN AMERICANS
OF WILMINGTON'S
EAST SIDE

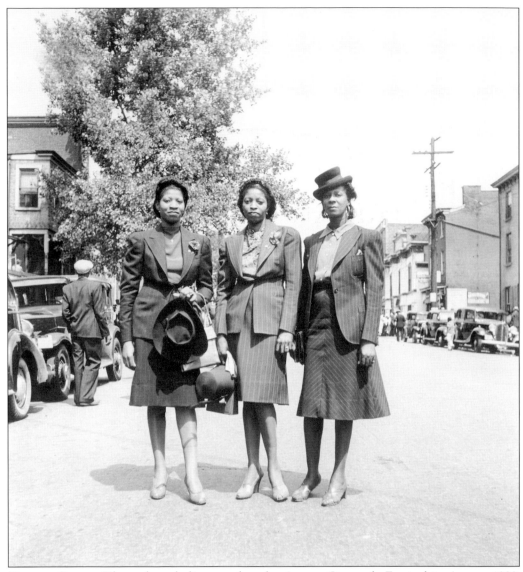

ON THE COVER: These three ladies posed at the August Quarterly Festival in August 1939. Dressing up for the festival was common because it represented dignity and pride of the Black race and a release from the shackles of slavery to religious freedom. Wearing hats completed the attire, which was also deeply rooted in the African religious tradition to honor God. The hat was a woman's crown that symbolized triumph over hardship and status—notable particularly among women in the African Methodist Episcopal culture. Some Black congregations on the East Side were known as "silk-stocking churches," indicative of the growing social and economic status of Wilmington's East Side. (Courtesy of the Delaware Historical Society.)

IMAGES
of America

AFRICAN AMERICANS OF WILMINGTON'S EAST SIDE

Hara Wright-Smith, PhD

ARCADIA
PUBLISHING

Copyright © 2022 by Hara Wright-Smith, PhD
ISBN 978-1-4671-0796-9

Published by Arcadia Publishing
Charleston, South Carolina

Printed in the United States of America

Library of Congress Control Number: 2021948270

For all general information, please contact Arcadia Publishing:
Telephone 843-853-2070
Fax 843-853-0044
E-mail sales@arcadiapublishing.com
For customer service and orders:
Toll-Free 1-888-313-2665

Visit us on the Internet at www.arcadiapublishing.com

To our ancestors and elders who overcame oppression and paved the way for a better life and a stronger community.

CONTENTS

ACKNOWLEDGMENTS

Grateful acknowledgement is expressed to many individuals and institutions that have contributed to this book. Among the contributors are families of the East Side, clergy and lay-leaders of Wilmington's East Side congregations, friends, and private and public collectors of historic information. Were it not for their support, this book would not have been possible.

I am truly thankful for those who invited me into their homes, places of employment, and houses of worship for in-person interviews as well as those who took time to participate in telephone, e-mail, and social media communications. In addition to my gratitude for the individuals and families acknowledged in each photograph caption, I would also like to thank the following individuals whose guidance was beyond measure: Dea. John Marshall; Regina Gray, Esq.; Maurice Gray Jr.; John Armstrong; Eugene Holley; Valerie Woodruff Noel; Mark Sills; Sandra Ballard; Dr. Jean Nutter; participating members of the Bethel AME Committee on Church History, including Betty Camper, Nancy Boyer, the late Carlton Guy, the late Catherine Barber, and Cheryl Burgess; Victoria Garrett; Rose Morgan; Doris Cannon; Bernard Pinkett; Edythe Pridgen; Leesa Kellam-Shephard; Larry Morris; Debbie Allen; Chi Davis; Patricia Bennett; Bishop Aretha Morton; Elder Janesta Ray; the late Marianne Johns; Eda Mae Robertson; Loretta Young; James Ray Rhodes; Max Moeller; Graham Connor; Diane-Louise Casson; Gilbert Williams; Ashlinn Steele Lorenzana; Valerie Harper; Frances McKinney Livingston; Vanetta Harper; Anesha Truesdale; and my sister Cheryl Wright.

I also extend gratitude for photographic services provided by Leigh Rifenburg and staff (Delaware Historical Society) and Curtis Small, Theresa Hessey, Maureen Cech, Dustin Frohlich, Valerie Stenner, and L. Rebecca Johnson-Melvin (Special Collections, University of Delaware Library, Museums and Press).

Special thanks are due to Rev. Dr. Lawrence Livingston, Bishop Dr. Silverster S. Beaman, Rev. Dr. Shirlyn Henry-Brown, Judge Alex Smalls, Darlene Webb, Bill and Iyoka Majett, Cheryl Burgess, Delores Tatman, Margaret H. Moore, Robyn Morris, and Leigh Rifenburg, whose belief in this topic, time, and continuous support culminated in this book. My sincere apologies to anyone who I may have missed who contributed to this work, as your support is appreciated.

I also warmly thank my husband, Darryl E. Smith, who recognized the importance of this work from the beginning and provided encouragement and unwavering support to the end.

INTRODUCTION

This book adds to the annals in history of Black life on Wilmington's East Side through the lens of family life experiences between the early 1900s and 1960s amid racial segregation and Jim Crow laws. The photographs represent an important but small contribution to this community's history and only touch upon a larger story. Preserving the memories and historic significance of the East Side and families who live there gives rise to conversations not only about the past, but potential for the future of this community. It attempts to capture the importance of positive self-image among residents who shared in a struggle for equality, dignity, and a common reverence for a place that faced an unforgiving degree of overt racism and discrimination that plagued all of Black America during this period.

This book geographically covers east of Market Street to Buttonwood Street between the Christina River to the south at Front Street to the south, and Brandywine Creek to the north at East Sixteenth, and covering portions of the Heald Street area. The East Side is a residential community with neighborhood-based small businesses scattered throughout the community. The community also claims historic districts and the establishment of row houses owned by many African American residents. The community enjoys notable structures that reflect major events in Wilmington's history, including the naming of parks like Herman Holloway Sr. Park, Kirkwood Park, and Kruse Pool (named after Edwina Kruse).

Most residents illustrated in this book migrated from Southern states, especially Maryland's Eastern Shore—towns like Centerville, Still Pond, Pond Town, Cambridge, and neighboring territories where ex-slaves and free-born people lived. Delaware had a well-defined system of segregation, and amid such conditions, East Side families showed a fierce determination to protect their families despite the injustices they were forced to endure. What emerged was a people who lived as an indigenous tribe. An elder from the community described the East Side as "people who lived next door to each other, around the corner and up the street from one another. Everything we needed was in the community like teachers who loved us; Black businesses who served us; medical, dental and legal services that healed and protected us; churches that provided spiritual, social and political cover for us; and relatives and neighbors who kept watch over us."

Social and political activism was essential to advancement and opportunity on the East Side. Many doctors, teachers, business owners, and lawyers successfully assumed elected offices, sitting on the Wilmington City Council to help inform decision-making about the well-being of African Americans in Wilmington. Members of the local chapter of the National Association for the Advancement of Colored People (NAACP) actively confronted injustice, inequality, and the fight to disrupt local and state legislative decision-making in Delaware. For example, Alice Nelson-Dunbar (wife of renowned poet Lawrence Dunbar) noted in a 1924 *Messenger* journal article that Wilmington had a population of 110,000 people with 11,000 Blacks. However, no Black policemen, firemen, or lawyers lived in the city. Decades later, the fight continued. Activists like Dr. Napoleon Gupton; Louis Redding, Esq.; and other leaders fought to get more African

Americans on Wilmington's police force throughout the 1950s. The Walnut Street Young Men's Christian Association (YMCA) welcomed local activists and provided a safe meeting place for Black people to gather, plan, and organize their efforts.

The two most important institutions in the lives of Delaware's Black people during the early 20th century were their schools and churches. Howard High School, listed in the National Register of Historic Places and designated as a national historic landmark, educated Black students in Wilmington and the state of Delaware for decades. Frederick Douglass Stubbs, the Bancroft School, Drew-Pyle Elementary, George Gray Elementary School, and other educational institutions ensured that African American students received the best-quality education possible in segregated Wilmington in the past as well as today. Likewise, the first Black church in Delaware was Ezion Methodist Episcopal Church, established in 1805 under the leadership of Rev. Peter Spencer and William Anderson. Together, they formed the Union African Methodist Episcopal Church (UAME) as a basis for religious freedom from segregation and independence in society. Bethel AME Church was established in 1846 under the founding of the African Methodist Episcopal Church by Right Rev. Richard Allen in 1816. These religious institutions, along with other houses of worship on the East Side, continue to serve the needs of the community.

By the late 1950s through the 1960s, the Wilmington Housing Authority acquired by purchase, eminent domain, or otherwise, land in sections of the East Side that resulted in the removal of residential properties, relocation of some church properties, and demolition of small businesses. During this period, urban renewal had a significant impact on the community, especially on the French Street corridor. French Street was historically a hub for Black-owned businesses, the August Quarterly celebration, and other social and economic activities for the Black community. The street closed to traffic between Seventh and Ninth Streets every year in August so that hundreds of worshippers and visitors could celebrate religious freedom and Black life. The aroma of down-home cooking and the heartbeat of gospel rhythms filled the streets. The August Quarterly festival is an ongoing tradition today and serves as a vivid reminder from "whence we came" and the importance of maintaining Black history. Despite social, economic, and political change from one generation to the next, people who were born and raised on the East Side will always have a story to tell shaped by a long history of racism in policies, practices, and laws. And still, they rise!

One

FAMILY LIFE OF EARLY SETTLERS

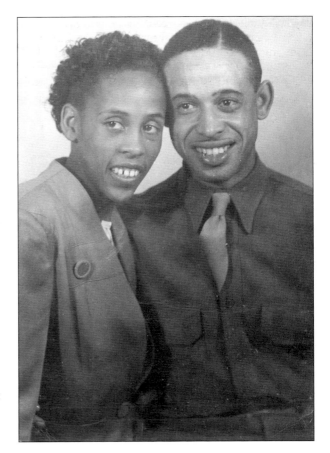

Littleton Mitchell joined the US Army Air Corps in the 1940s and honorably served during World War II as a member of the distinguished Tuskegee Airmen. Mitchell returned to Wilmington after his tour of duty to address equal justice and issues of race in Delaware. He worked closely with his friend Louis L. Redding, Delaware civil rights attorney. Mitchell married Jane Watson, who was also a civil rights activist. Jane (Watson) Mitchell, pictured here with her husband in the 1940s, participated in sit-ins and protests and was a longtime leader of the Delaware NAACP, where she fought for equal medical treatment for Black people in the state. (Courtesy of the Delaware Historical Society.)

Howard High School

Wilmington, Delaware

Littleton P. Mitchell

having satisfactorily completed the requirements
for graduation, is awarded this

Diploma

Given this thirteenth day of June, A.D., 1939.

Geo. A. Johnson
Principal

S. M. Stouffer
Superintendent

Harry C.
President Board of Education

Littleton Mitchell graduated from Howard High School on June 13, 1939. Howard High was the only high school for Black students in segregated Wilmington at the time. Mitchell led the Delaware state branches of the NAACP for over 30 years and fought to address equal rights, fair housing, school desegregation, equal access to public accommodations, voting rights, and increased employment and educational opportunities for African Americans in Delaware. (Courtesy of the Delaware Historical Society.)

Howard High School

Wilmington, Delaware

Jane E. Watson

having satisfactorily completed the requirements
for graduation, is awarded this

Diploma

Given this fifteenth day of June, A.D., 1938.

Geo. A. Johnson
Principal

S. W. Stouffer
Superintendent

Harry B. Eaton
President Board of Education

Jane Watson graduated from Howard High School on June 15, 1938. She earned her bachelor's degree from the University of Delaware in 1963 and a master's degree from Washington College in 1969, and became the first African American registered nurse in the Delaware hospital system. Former senator Joseph R. Biden, who later became the 46th president of the United States, delivered the eulogy at her funeral in 2004. (Courtesy of the Delaware Historical Society.)

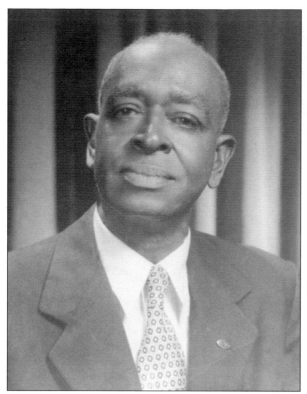

Wittie Johnson and his wife, Beatrice, moved with their family to the East Side from Burgard, North Carolina, in the early 1930s in search of economic opportunity. Johnson, pictured here in the 1960s, secured a blue-collar job at the Wilmington Dupont plant where he worked for more than 30 years until his retirement. (Courtesy of Marguerite Comegys.)

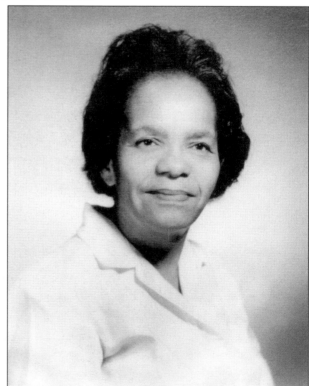

Beatrice Johnson is pictured here in the 1960s. The Johnsons lived at 332 East Seventh Street. (Courtesy of Marguerite Comegys.)

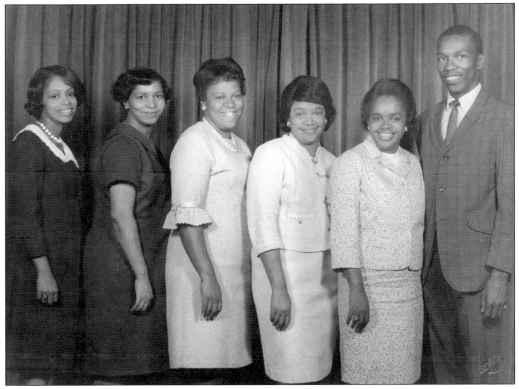

Pictured in this 1958 portrait are Wittie and Beatrice Johnson's adult children. From left to right are Lola Miller, Mary Bailey, Dorothy Gross, Christine Stansbury, Marguerite Comegys, and James Henry Johnson. (Courtesy of Marguerite Comegys.)

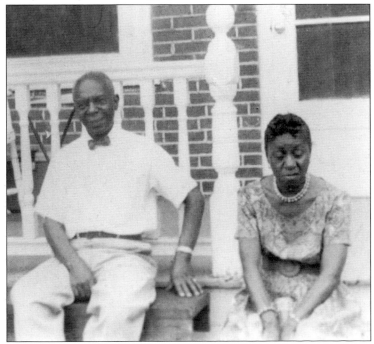

Morris and Clara Comegys are sitting on the front step of their home at 1206 Walnut Street on a summer evening in the 1960s. (Courtesy of Marguerite Comegys.)

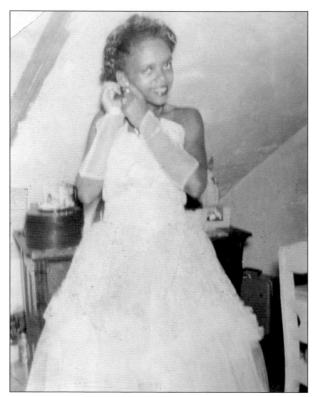

Born in 1936, Marguerite Johnson is primping on her wedding day at her family home at 332 East Seventh Street. She married Morris Comegys Jr. on June 27, 1953. (Courtesy of Marguerite Comegys.)

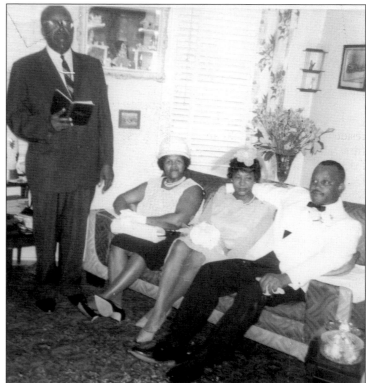

Officiating weddings in the home was a common practice on the East Side in the early 20th century. Seen here, Rev. William Majett Sr. prepares to officiate a wedding ceremony. (Courtesy of William Majett Jr.)

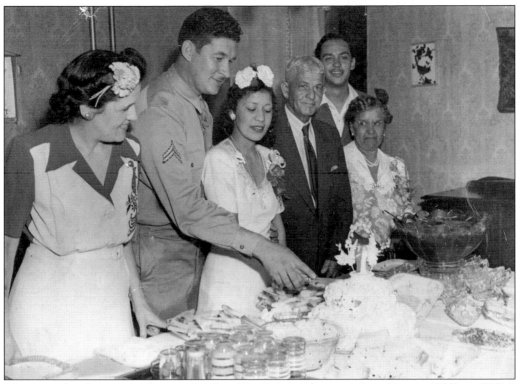

The Dean family were residents at 512 East Ninth Street for more than 60 years. William "Billy" Dean and Ethelda "Ted" Dean (center, cutting cake) enjoy their wedding reception at home in 1944. Family gathered around them are, from left to right, Ethel Dean, Bertha Street, Robert Dean, and William Street. Pictured here in his uniform, William Street was a World War II US Army corporal assigned to Southeast Asia with honors. Renowned trumpeter from the East Side Clifford Brown practiced on occasion at the Dean residence because the family had a baby grand piano at their home. (Courtesy of Ron Dean.)

Gathered at the Dean family residence from left to right are (first row) Evelyn; (second row) Ethelda "Ted," Vernon, and Dorothy; (third row) Gladys, Marjorie, Lela, and Percell. Prior to becoming a teacher at Bancroft School, Ted worked at Piane Caterers as a waitress, banquet coordinator, and accounts manager in the 1950s. She was very active in helping people from the community get employment at Piane. The Deans were political advocates, participating in the March on Washington with Rev. Martin Luther King Jr. on August 28, 1963. (Courtesy of Ron Dean.)

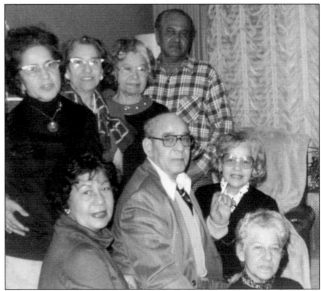

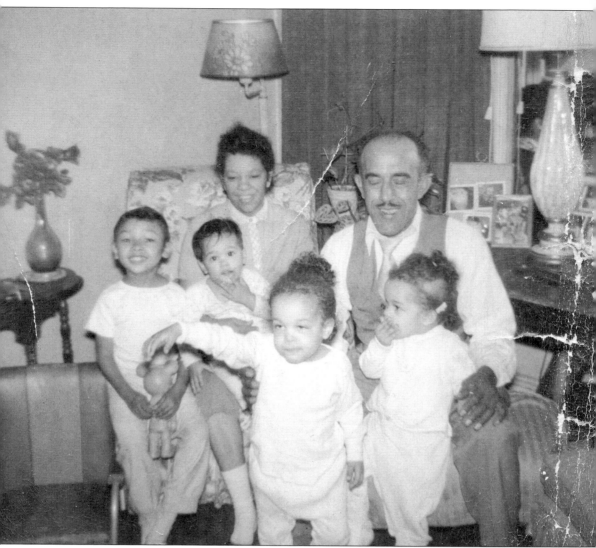

Howard and Helen Street and their children are pictured here in the 1960s. From left to right are (first row) Sharon and Sheila; (second row) Michael, Howard Jr., and Howard; (third row) Helen. The Street family purchased their home at 512 Taylor Street on March 25, 1947. Married on December 26, 1941, Howard Sr. worked as a delivery man for H. Feinberg Furniture Company and Helen held various occupations, including homemaker, teacher's assistant, and a day care worker at Grinnage Daycare on Lombard Street. (Courtesy of Sharon L. Street-Wright.)

The Elliott family lived at 505 East Fifth Street for more than 40 years. This photograph shows Herbert and Mabel Elliott with their daughter Cynthia Elliott. Cynthia Elliott-Oates was born and raised on the East Side and became an educator in Wilmington public schools, serving more than 18 years as a teacher and later as a board member of the Christina School District. Elliott-Oates is a community leader who also serves on the board of the East Side's Redding House Museum and Community Center on East Eleventh Street. (Courtesy of Cynthia Elliott-Oates.)

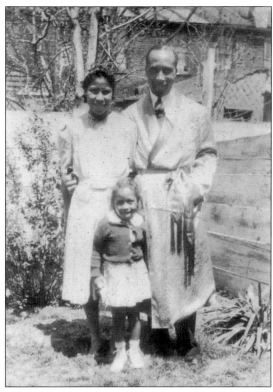

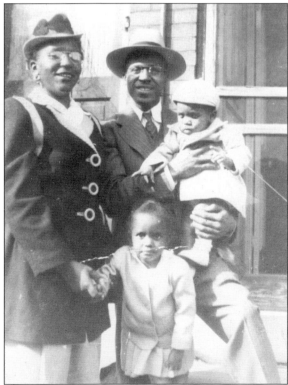

Charles and Jeanette Dorsey were born and raised in Still Pond, Maryland. The couple moved to Wilmington and purchased a home at 916 Poplar Street in 1945 where they lived for more than 30 years. The Dorseys are pictured here with their children Charles Jr. and Blanche. Charles Sr. worked at the Wilmington Container Corporation on East Twelfth Street until his retirement, and Jeanette was a licensed hairdresser. (Courtesy of Kevin Dorsey.)

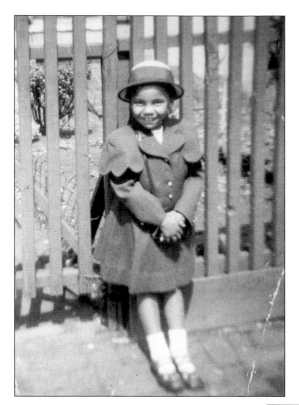

This is five-year-old Gloria Smith on Easter Sunday in 1950. Smith lived at 416 East Eleventh Street and recalls walking with her grandmother daily to the Cramer house to take their elderly neighbor dinner. (Courtesy of Gloria Smith.)

Catherine (Smith) Barber was 30 years old in this photograph. She was born in 1921 in the East New Market–Cambridge, Maryland, area, and when she was eight years old, she and her family moved to Wilmington's East Side. The family settled at 416 East Eleventh Street where Catherine lived all her life. She was a longtime member of Bethel African Methodist Episcopal Church and was recognized as the "Mother of the Church" until her death on December 23, 2017. (Courtesy of Gloria Smith.)

This is a 1930s photograph of Edward Smith, Catherine (Smith) Barber's father. (Courtesy of Gloria Smith.)

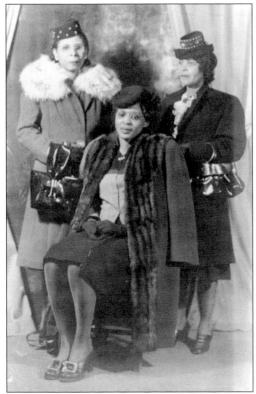

This photograph shows Catherine Barber's sisters adorned in their Sunday best. From left to right are Alberta, Beatrice, and Lillian in the 1930s. (Courtesy of Gloria Smith.)

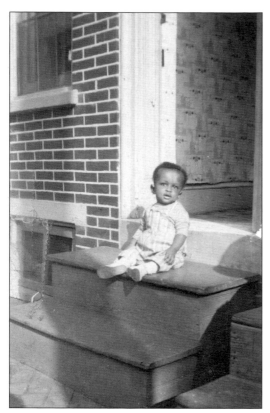

In 1944, one-year-old William Majett Jr. is sitting on the front steps of the family home at 1026 Bennett Street. Majett grew up with close neighbors, friends, and family and enjoyed activities at the Walnut Street YMCA. He recalled neighborhood elders like Doc Hill, who lived on East Tenth Street, and John Frisby, who lived at the Walnut Street YMCA. (Courtesy of William Majett Jr.)

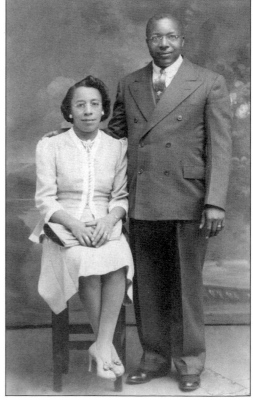

Ethel and William Majett Sr. moved from Snow Hill, Maryland, to the East Side in 1933. After living with relatives, they purchased their home at 1026 Bennett Street in 1945. Majett Sr. worked at a local slaughterhouse and shipyard and also earned his preaching license and joined a community of clergy in Wilmington. Ethel was an organist at the Mount Carmel Methodist Episcopal Church. (Courtesy of William Majett Jr.)

This portrait of Walter Mando was taken in the 1930s. Mando purchased a home at 1242 Wilson Street where he and his wife, Mary Lee, and their family lived for more than 30 years. Mando was a corporal in the US Army in 1918, and following his military career, he worked at the Monday Brothers Furniture Store. (Courtesy of Paul and Faith Loper.)

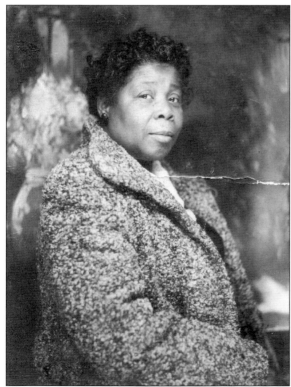

This is a 1960s photograph of Mary Lee Mando, wife of Walter Mando. (Courtesy of Paul and Faith Loper.)

Nettie Bomar-Smith (far right) is pictured here with her mother and sisters at home on Bennett Street. From left to right are Tessie Bomar, Hortense (Bomar) Paden, Emma Bomar, and Luvenia Bomar. Nettie Bomar moved from Inman, South Carolina, to Wilmington's East Side in the 1950s. (Courtesy of Tanya Williams.)

Nettie and Wilson Smith Jr. purchased their home on Bennett Street. Wilson Smith was a decorated Army veteran in the Vietnam War. He developed a deep passion for recognizing the sacrifice and valor of African American military heroes, and dedicated years advocating for change. As a result of his activism, in 1996 a national monument for Black war heroes was erected at the Pentagon in Washington, DC. Eighty-five African American recipients of the Medal of Honor were featured in a permanent exhibit. Pres. Bill Clinton recognized Smith for his efforts, praising him for fighting selflessly to lead the forces of freedom to victory despite the freedom they did not have in their own country. (Courtesy of Tanya Williams.)

A Mr. Roe is standing in front of his house at 1026 Bennett Street in the 1950s. He was known for taking time to stop and talk with neighbors. Roe had pride in his neighborhood. He was often seen cleaning up the streets on the East Side. (Courtesy of William Majett Jr.)

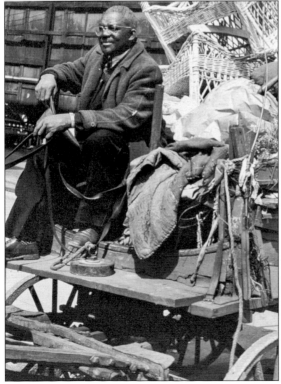

This man was a neighborhood junk collector in Wilmington in the late 1930s–1940s. Dressed in a suit and necktie, he was known to travel in a horse drawn cart picking up furniture and other items discarded by neighborhood residents. (Courtesy Lynn Nzingha Hopkins-Collins.)

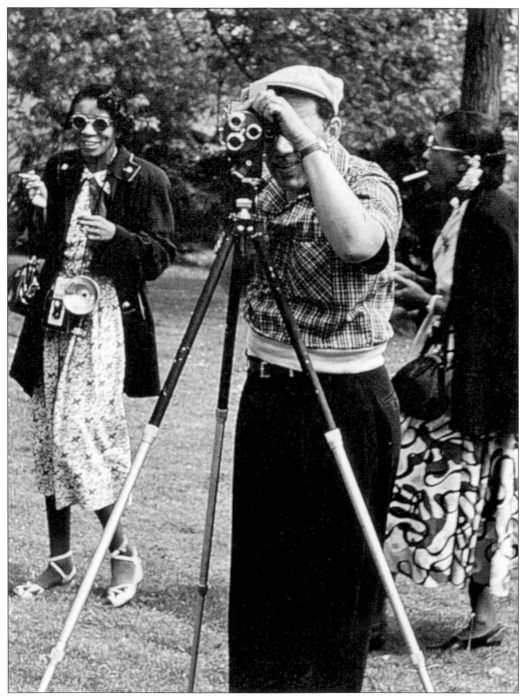

This 1954 photograph shows Edwin Anderson filming an outdoor gathering of Black photographers from the East Side. Anderson was the managing editor of *CANDID*, one of the first Black photograph news magazines in the United States during the 1930s. Joining him at the event are Anderson's wife, Libby (right), and Libby's sister Lorraine Hamilton (left). Edwin was a graduate of Lincoln University in Pennsylvania where he later taught professional photography. Lorraine was a teacher. (Photograph by John O. Hopkins Jr.; courtesy of Lynn Nzingha Hopkins-Collins.)

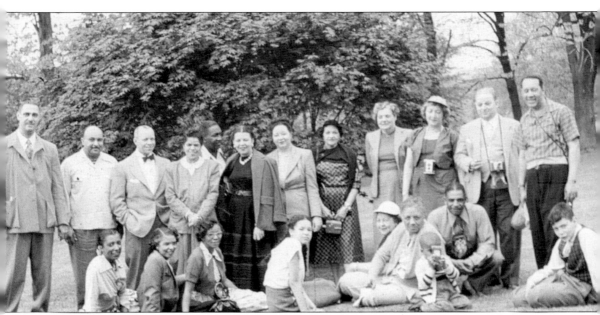

These Black photographers from the East Side and citywide were members of the Wilmington Black Camera Club. They gathered in a local park for an annual event. (Photograph by John O. Hopkins Jr.; courtesy of Lynn Nzingha Hopkins-Collins.)

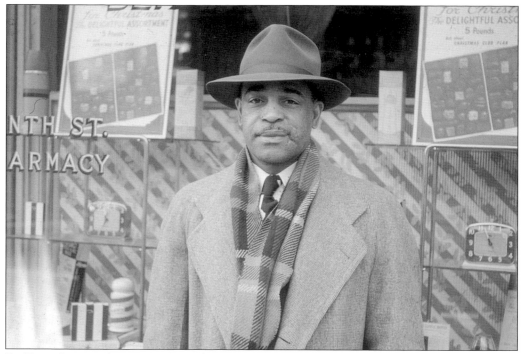

Dr. Foster Brown, pharmacist, is standing in front of the Ninth Street Pharmacy in Wilmington in the 1950s. Dr. Brown lived at 824 Lombard Street. (Photograph by John O. Hopkins Jr.; courtesy of Lynn Nzingha Hopkins-Collins.)

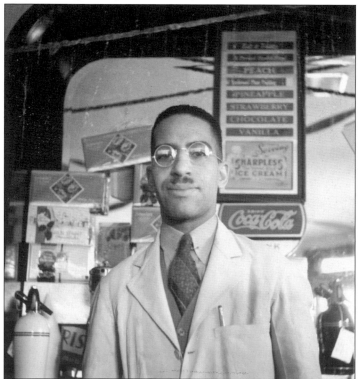

In June 1939, Dr. John L. Davidson, pharmacist, is shown standing at the service counter at the Ninth Street Pharmacy where he worked and managed. (Courtesy of the Delaware Historical Society.)

August Hazeur was a pharmacist in Delaware from 1958 to 1976. He worked at several pharmacies, including Sun Ray Drugs at Fifth and Market Streets, West Tenth Street Pharmacy, and Claymont Pharmacy. (Courtesy of August Hazeur.)

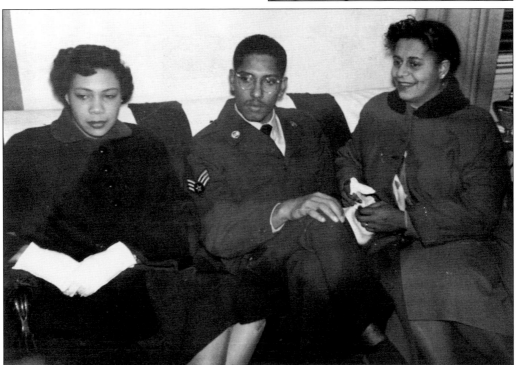

August Hazeur (center) served in the US Air Force in the radio mechanics field and as a senior pharmacy specialist. In this photograph, he is nestled on the sofa between cousin Barbara Baden (left) and his wife, Kathryn. (Courtesy of August Hazeur.)

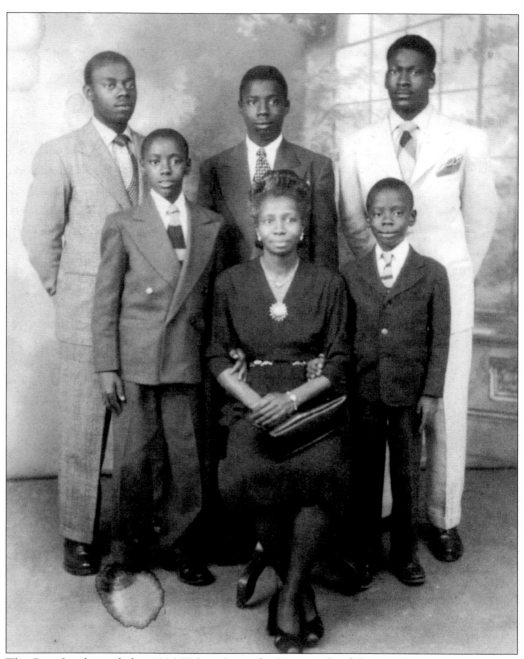

The Gray family resided at 1306 Wilson Street for 26 years. Cecil Spence Gray (center) is seated surrounded by her children. From left to right are (first row) Maurice and Paul; (second row) Bruster, Horace, and Ted. Maurice was a 1956 graduate of the Philadelphia College of Pharmacy and Science. He was licensed in the state of Delaware, became a registered pharmacist in 1958, and worked in the profession until his retirement in 1988. He reflected on his experience as a Black pharmacist in Delaware, stating that Black pharmacists did not earn the same wages as White pharmacists. They worked longer hours and often out of public view because some customers did not want their prescriptions filled by Black pharmacists. Maurice noted that his career represented "hope in the face of despair." (Courtesy of the Gray family.)

Dr. B. Napoleon Gupton, a chiropodist (known today as a podiatrist), is seen here attending a Wilmington political dinner in 1966 with his wife, Mayme Sommerville-Gupton, who was a former fashion designer. Dr. Gupton was also a Wilmington city councilman, serving the East Side, parts of South Wilmington, and the fourth district from 1964 to 1970. Among many issues that he sought to change were police-community relations and advocating for racial balance on the Wilmington police force. Gupton died before that legislation passed. (Courtesy of Judith Gupton-Wiley.)

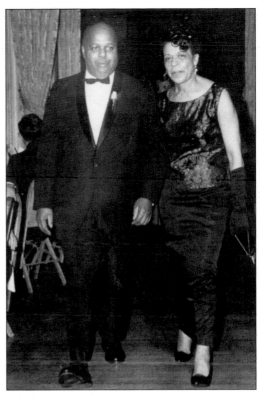

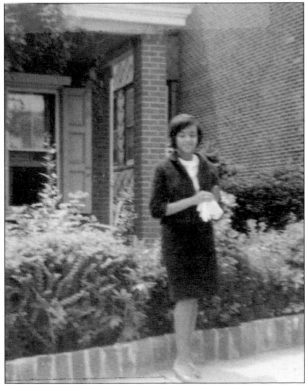

Judith Gupton (daughter of Dr. B. Napoleon and Mayme Sommerville-Gupton) is standing outside her parents' home at 206 East Tenth Street in 1964. She was an educator and taught at Howard High School. (Courtesy of Judith Gupton-Wiley.)

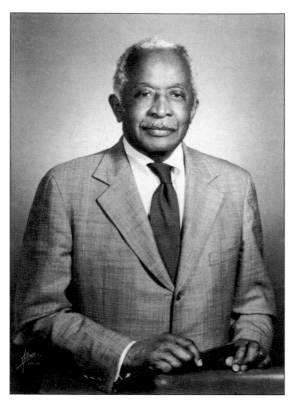

Louis L. Redding, Esq., was the first African American attorney in the state of Delaware. He was born in Alexandria, Virginia, in 1901 and lived most of his life at 203 East Tenth Street. Redding graduated from Howard High School in 1919, attended Brown University, and graduated with honors in 1923. He later earned his law degree from Harvard Law School in 1928. As a civil rights pioneer, Redding successfully argued desegregation cases in Delaware, including the 1950 *Parker v. University of Delaware*. His groundbreaking *Gebhart v. Belton* case contributed to the landmark 1954 US Supreme Court *Brown v. Board of Education* case, which changed federal public policy regarding "separate but equal." (Courtesy of the Delaware Historical Society.)

This is the Redding House Museum and Community Center at 310–312 East Eleventh Street. The museum was established by the Redding Housing Foundation Inc. to honor the Redding family's contributions to civil rights, education, literature, and culture. The center offers tours of the museum, lectures, youth mentoring, tutoring, and other activities. (Author's collection.)

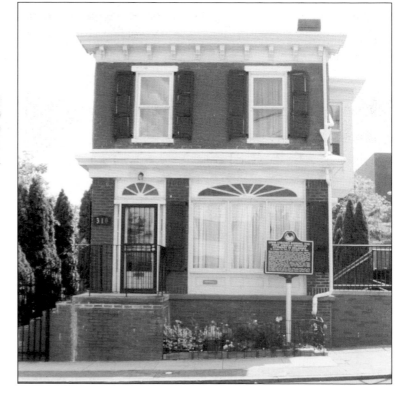

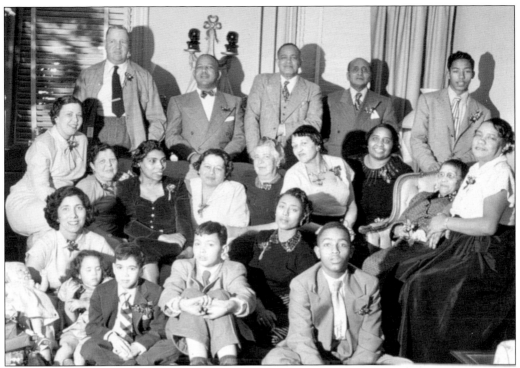

The Hopkins family is gathered to celebrate Christmas in the 1950s. (Photograph by John O. Hopkins Jr.; courtesy of Lynn Nzingha Hopkins-Collins.)

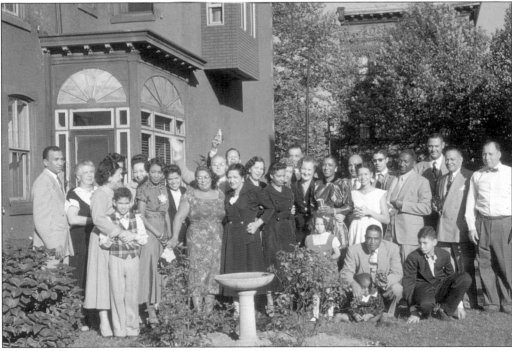

This c. 1950s photograph shows a gathering of Wilmington residents from both the East Side and West Side. (Photograph by John O. Hopkins Jr.; courtesy of Lynn Nzingha Hopkins-Collins.)

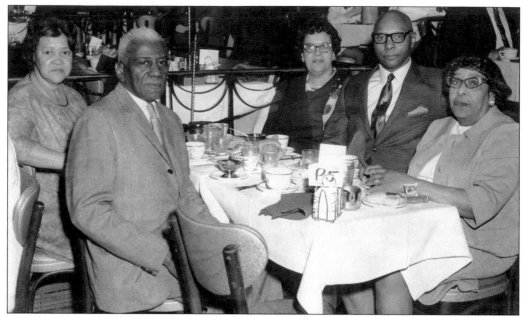

The Smith and Thompson families enjoy a night out together in the 1960s. From left to right are Martha and Lawrence Smith, Emmitt and Samuel Thompson, and unidentified. (Courtesy of Carol [Smith] Latney.)

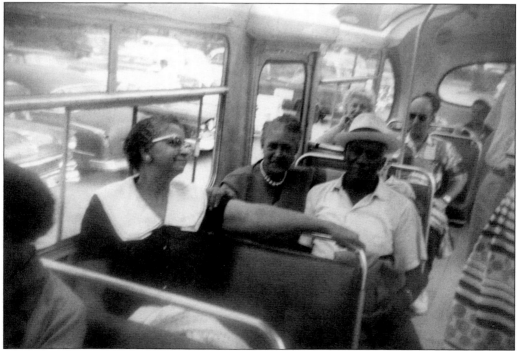

This photograph shows Lawrence and Martha Smith seated together on a bus and having a conversation with another passenger. The Smiths resided at 1231 French Street for more than 30 years. (Courtesy of Carol [Smith] Latney.)

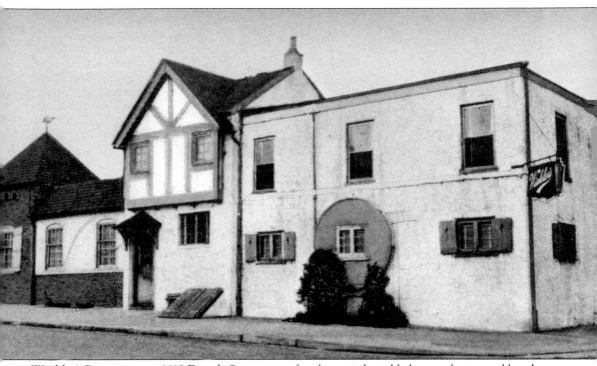

Winkler's Restaurant at 1419 French Street was a family-owned establishment that served lunch, cocktails, and dinner for more than 30 years. Lawrence and Martha Smith were employees at Winkler's for more than 26 years. Chef Lawrence ran the kitchen and managed a staff of 10, and Martha was the salad and pastry specialist. Winkler stated in a May 3, 1963, *Wilmington News Journal* article, "We know we have the best chef in town. For good, straight cooking he can't be beat." (Courtesy of Special Collections, University of Delaware Library, Museums and Press.)

Pictured here in the 1940s is Coleman E. Smith, son of Lawrence and Martha Smith, who lived with his parents at 1231 French Street. He attended Howard High School and went on to work at General Motors until his retirement in 1992. GM provided manufacturing jobs for many Black working-class families at the time. (Courtesy of Sherry [Smith] Dorsey.)

Herman Holloway Sr. and Herman Holloway Jr. facilitate a ribbon-cutting ceremony with local Wilmingtonians. They are joined by Delaware senator Mike Castle and Maj. Harry G. Haskell. Herman Holloway Sr. (1922–1994) was known by many Delawareans as the "Dean of Black Politicians in Delaware." In 1964, he became the first Black elected to Delaware's state senate, representing the second district of New Castle County. Holloway spent nearly 30 years in the Delaware legislature as a representative and senator. (Courtesy of Vincent Robinson.)

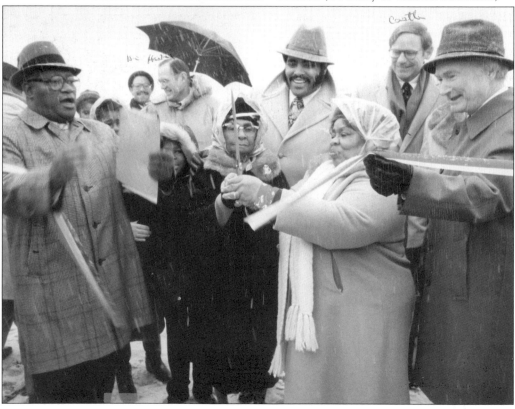

The Debrick family purchased their home at 408 Shearman Street in the early 1950s. Pictured here are, from left to right, (first row) Kim Debrick (now known as Nzinga Debrick) and Sheila Debrick (now known as Hanifa Shabazz); (second row) Van Debrick Jr., Sandra Debrick Croffett, Jacqueline Debrick Sudler, E. Patricia Debrick, Van Debrick Sr., and Rovella Debrick. Residents who lived on the street were affectionately known as "Shearman Street Families." Shearman Street had little traffic, which allowed kids to play uninterrupted street games. Since this photograph was taken more than 50 years ago, Hanifa Shabazz became the first female city council president in Wilmington's history. (Courtesy of Jacqueline Debrick Sudler and Hanifa Shabazz.)

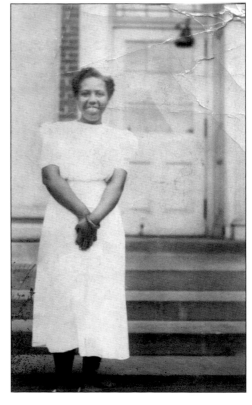

Priscilla Dorsey-Bolden is shown standing in front of Howard High School where she graduated in 1938. Dorsey-Bolden worked at the East Side's Allied Kid Company. (Courtesy of Madeline Bolden-Johnson.)

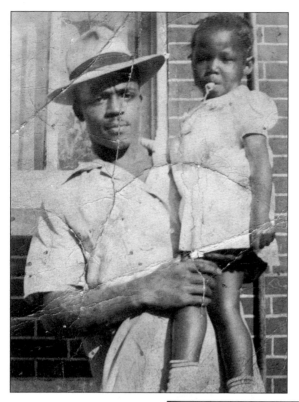

Charles Bolden, husband of Priscilla-Dorsey Bolden, is shown holding their three-year-old daughter Madeline in the 1930s. The Bolden family purchased their home at 501 Shearman Street in 1935; five generations of the family have lived there. Charles worked for the Pennsylvania Railroad. (Courtesy of Madeline Bolden-Johnson.)

Cheris Harrison (left) and Bettyann Young pose in the 500 block between Shearman and Pine Streets in the early 1950s where they lived and enjoyed playing street games. Cheris Harrison-Congo grew up to become owner and operator of Congo Funeral Home with her husband Ernest M. "Sammy" Congo. Congo Funeral Home has become a leader in funeral service throughout Wilmington and surrounding areas. (Courtesy of Cheris Congo.)

Viola Loper is standing with sons Edward (left) and Kenneth in front of their home at 1221 Heald Street in the early 1940s. She was raised in Pond Town, Maryland, and spent her adult life on Wilmington's East Side. Edward Loper Jr. was born in December 1934 and attended neighborhood schools on the East Side. He graduated from Howard High School in 1954. Edward had a gift for drawing and became a self-taught artist. He emerged as a master of oil paintings, renowned for his use of color. (Courtesy of Edward Loper Jr. and James Loper.)

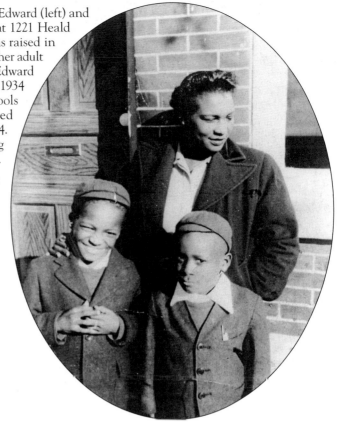

Edward Loper Jr. created this sketch of the Eleventh Street Bridge area in the 1960s; it was titled *Birdseye*. Loper walked the neighborhoods surrounding Heald Street where he lived, memorized street patterns, and produced this rendering. He recalled that Black families lived in wood-frame houses near the marshland, which was a yellow-ditch mosquito pond, earning the community the nickname "Frogtown." Residents were called "froggies" because of the croaking frogs that woke up many people in the morning. (Courtesy of Edward Loper Jr. and James Loper.)

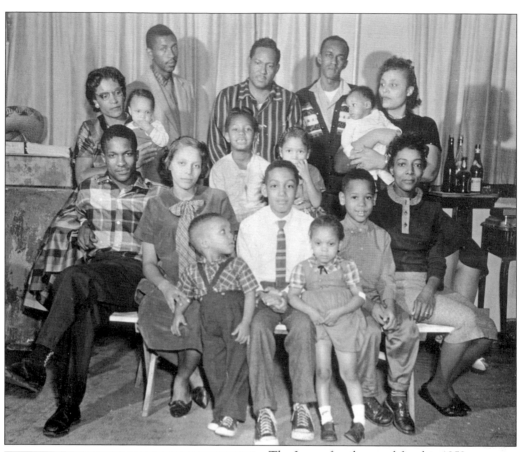

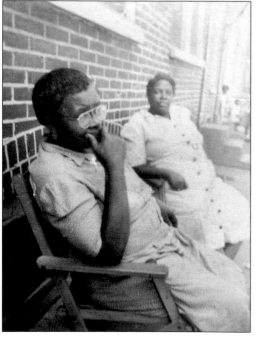

The Loper family posed for this 1959 photograph. From left to right are (first row) Edward Loper III, Jean Loper; Edward Loper Jr., Barbara Naylor Loper, Edward Loper III, Bunny Bruton, Jean Loper, Curtis LaFate, and Jean Loper Washington; (second row) Claudine Bruton Loper, Muriel Loper, Debbie Loper, and Renee LaFate; (third row) Robert "Robbie" LaFate, Edward Loper Sr., and James Washington. Loper Sr. was an accomplished artist for 70 years and a teacher known for his vibrant use of colors. His paintings are displayed in museums and in public and private collections. (Photograph by Hezekiah Burton; courtesy of Edward Loper Jr. and James Loper.)

Hanna Jane Bratcher (left) was Edward Loper Jr.'s grandmother. In this 1942 photograph, she is in her rocking chair outside her East Side home chatting with Marion E. Scott. (Courtesy of Edward Loper Jr. and James Loper.)

Dressed in their Sunday best in this 1942 photograph are Doris (Johns) Mason (left) with sister Marlene (Johns) Wiggins. (Courtesy of Joyce Clark.)

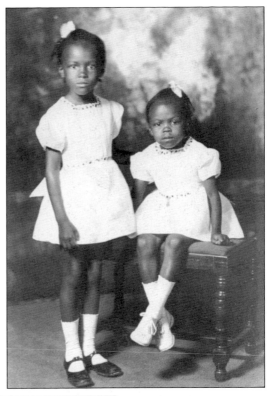

This 1950s photograph shows sisters four-year-old Alease (Johns) Collins and three-year-old Joyce (Johns) Clark standing on the steps that led to the backyard of their home at 1020 Wilson Street. (Courtesy of Joyce Clark.)

Maryanne Johns posed for this school picture in 1953 at age 10. She attended School No. 29 and grew up to become a secretary and administrator in the Wilmington public school system. (Courtesy of Joyce Clark.)

The photographer titled this photograph "Three East Side Republicans." After the Civil War, Republicans passed laws that granted protections for Black Americans and advanced social justice. The realignment of Black voters from the Republican Party to the Democratic Party that began in the late 1920s proliferated during this era. (Photograph by John O. Hopkins Sr.; courtesy of Lynn Nzingha Hopkins.)

Thelma Willis (left) and Ola Mae Wilson lived on Locust Street on the East Side. Locust Street was commonly known as "The Hoodle" by local residents. This 1949 photograph shows the women standing in front of Zallea Brothers Inc., a metal fabricating plant at Taylor and Locust Streets. (Courtesy of Elsie Thomas.)

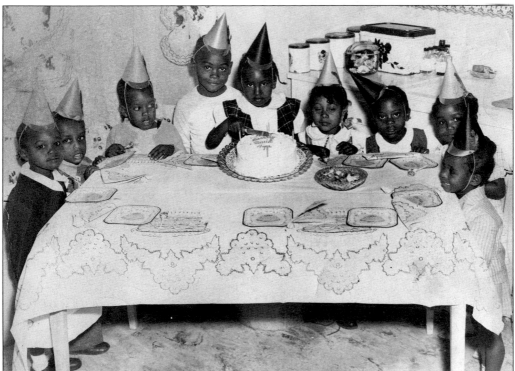

Muriel Taliferro (center, cutting cake) is enjoying her birthday celebration with her friends from the East Side. (Courtesy of William Majett Jr.)

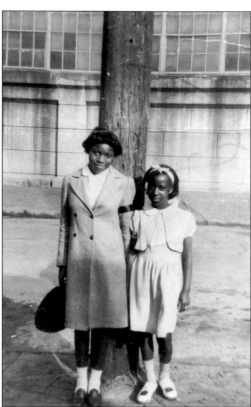

Pictured are Mary Matthews (left) and Elsie (Cooper) Thomas standing in front of Zallea Brothers Inc. around 1942. (Courtesy of Elsie Thomas.)

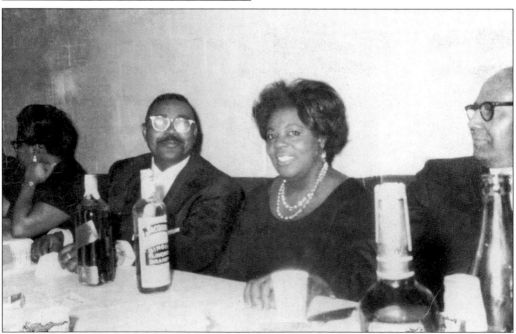

This 1959 photograph shows James Cooper (second from left) enjoying his retirement with family and friends after working more than 30 years as a crane operator with Zallea Brothers Inc. The Cooper family resided at 823 Locust Street. (Courtesy of Elsie Thomas.)

Rodney Rouselle resided at Tenth and Walnut Streets. This photograph was taken in the 1950s. (Courtesy of Cynthia Elliott-Oates.)

Willa Mae Connor is shown standing on the street near Butlers Print Shop at Tenth and Lombard Streets around the 1950s. (Courtesy of Cynthia Elliott-Oates.)

Bobby and Maurice Butler are standing in front of their father's print shop on Lombard Street in the 1950s. (Courtesy of Cynthia Elliott-Oates.)

This resident of Lombard Street, Bessie Tribbit, is standing in front of Butler's Print Shop. (Courtesy of Cynthia Elliott-Oates.)

ReTha Mae Williams, a resident of Lombard Street, is standing in front of Butler's Print Shop. (Courtesy of Cynthia Elliott-Oates.)

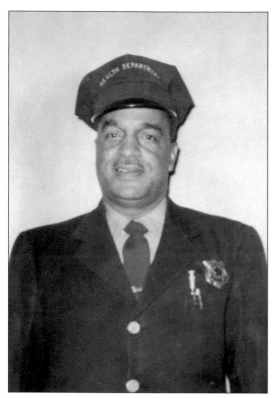

William Lewis Sr. and his wife, Lennie, bought their home at 937 Spruce Street in 1959. The family remain the owners. William was a Wilmington health inspector for 23 years and was employed as a personnel specialist for Hercules Inc. from 1962 until his retirement in 1975. He served on the former Wilmington Board of Education and was an executive committee member of the Wilmington Branch of the NAACP in the 1930s. He has been recognized for his decades of community service, which includes naming the William Lewis Elementary School at 920 North Van Buren Street in his honor. (Courtesy of Marita Lewis.)

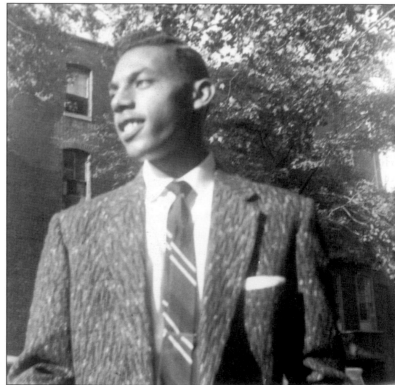

This September 1956 photograph shows William Lewis Jr., the adult son of Lennie and William Lewis Sr. (Courtesy of Marita Lewis.)

Two

BLACK-OWNED BUSINESSES AND ENTREPRENEURS

John O. Hopkins Sr. is seen standing on an East Side street. He was recognized as one of Delaware's most influential business, civic, and political figures of the early 20th century. Inspired by his love and devotion to the East Side community, Hopkins helped pave the way for African Americans in segregated Wilmington. Hopkins owned Hopkins Theatres, which were the only movie theaters for Blacks in Wilmington at the time. From 1913 to 1945, Hopkins served on the Wilmington City Council. According to a 1940 *News Journal* article, Hopkins promised voters that if elected he would see that more Blacks were placed on the city payroll. Total earnings of Black employees at the time were less than $1,000 a year. He kept his promise. After 27 years of unceasing efforts, by the early 1940s Blacks were employed in practically every branch of local government, and the city payroll was more than $219,000. (Courtesy of Lynn Nzingha Hopkins-Collins.)

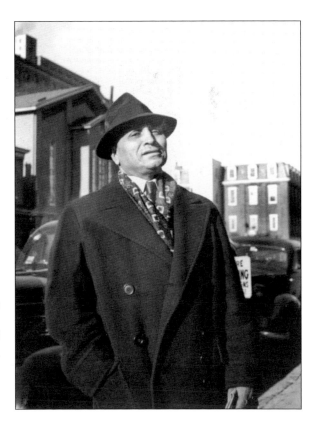

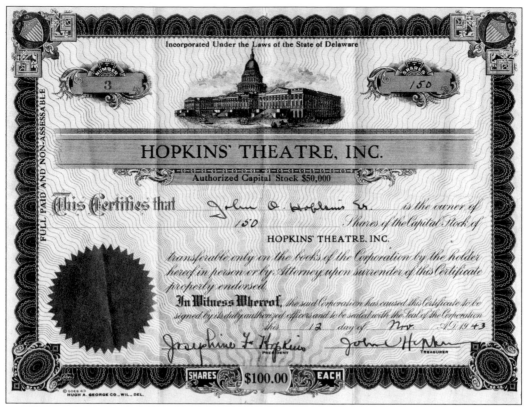

Incorporated Under the Laws of the State of Delaware

NUMBER 3

SHARES 150

HOPKINS' THEATRE, INC.

Authorized Capital Stock $50,000

FULL PAID AND NON-ASSESSABLE

This Certifies that _John O. Hopkins Sr._ is the owner of _150_ Shares of the Capital Stock of

HOPKINS' THEATRE, INC.

transferable only on the books of the Corporation by the holder hereof in person or by Attorney upon surrender of this Certificate properly endorsed

In Witness Whereof, the said Corporation has caused this Certificate to be signed by its duly authorized officers and to be sealed with the Seal of the Corporation this _12_ day of _Nov._ A.D. 19_43_

Josephine F. Hopkins
PRESIDENT

John O. Hopkins
TREASURER

SHARES $100.00 EACH

© GOES 43
HUGH A. GEORGE CO., WIL., DEL.

This stock certificate for Hopkins Theatre Inc. is dated November 1943. (Courtesy of Lynn Nzingha Hopkins-Collins.)

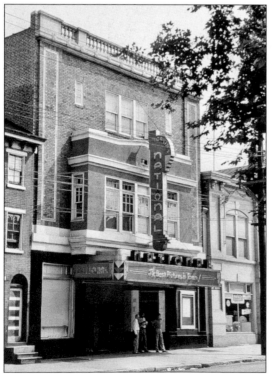

Pictured is Hopkins National Theatre at 810–822 French Street—Wilmington's only Black-owned movie theater at the time. This 600-seat structure had an exterior ticket booth staffed by Hilda Fisher (cashier) and Howard Lee (manager). By 1950, the building was restructured to make room for a newer, more modern theater. (Photograph by John O. Hopkins Sr.; courtesy of Lynn Nzingha Hopkins-Collins.)

This is the renovated Hopkins theater at 810–822 French Street. Hopkins transferred ownership to his son John O. Hopkins Jr., and after decades of service to the community, the theater was sold to the Wilmington Housing Authority in July 1965. (Photograph by John O. Hopkins Jr.; courtesy of Lynn Nzinga Hopkins-Collins.)

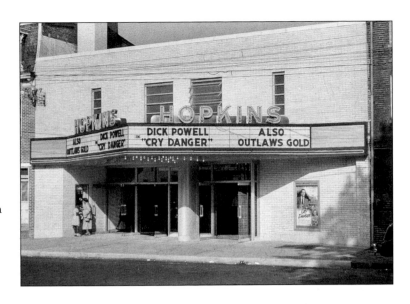

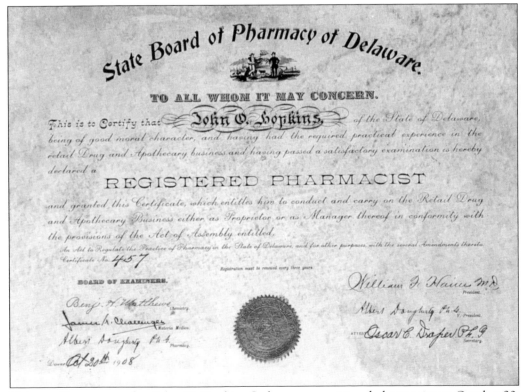

This certificate states that John O. Hopkins Sr. became a registered pharmacist on October 20, 1908. Among his many professional accomplishments, Hopkins was a graduate of the Philadelphia College of Pharmacy. (Courtesy of Lynn Nzingha Hopkins-Collins.)

This 1943 photograph shows the exterior of Phillips restaurant, a family business owned by Charles and Estell Phillips. Located on Second and Poplar Streets, the restaurant was known for its homemade soul food and specialties that included fried chicken, pork chops, meat loaf, and fried fish. Workers from both Wilmington's Pusey and Jones shipbuilding companies and Synvar Chemical were frequent lunch and dinner patrons. Shown standing in front of the restaurant are, from left to right, Wendell Phillips, seven-year-old Castella Holloman, and Lola Houston, nieces and nephew of the owners. Phillips restaurant served the community for more than 20 years before closing in the early 1960s. (Courtesy of Castella LeCompte and Phyllis Tann.)

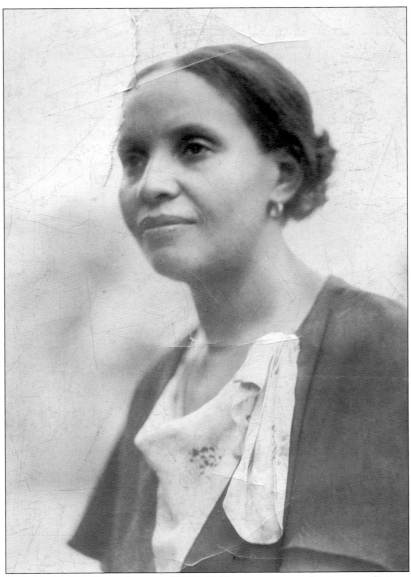

Shown here in the 1940s, Irma Lawson (1897–1961) was active in business, politics, social, and religious life in Wilmington for more than three decades. She was owner and operator of the Lawson Hotel at 208 Poplar Street and the Lawson Domestic Training School and Employment Bureau at 918 French Street. Listed in the 1954 *Negro Travelers' Green-Book* (a guide to travel and vacation for Black travelers), the Lawson Hotel provided safe lodging and a place for Black travelers to dine during segregation. Lawson's community activism in segregated Wilmington included serving as second vice president and later vice president of the NAACP's Wilmington branch, secretary of the USO Citizens' Committee on Civilian Defense Aid, staff assistant and Gray Lady of the American Red Cross, and foster mother with the Catholic Board of Charities. She helped desegregate Salesianum High School in 1950 and worked on John F. Kennedy's 1960 presidential campaign. Lawson was also a correspondent for both the *Afro-American* and the *Sunday Star* newspapers. She later became a clerk for the New Castle County treasurer's office—the first Black woman to serve in that capacity—in the 1940s. Lawson was also a member of St. Joseph Catholic Church. (Courtesy of the estate and family of Irma Lawson.)

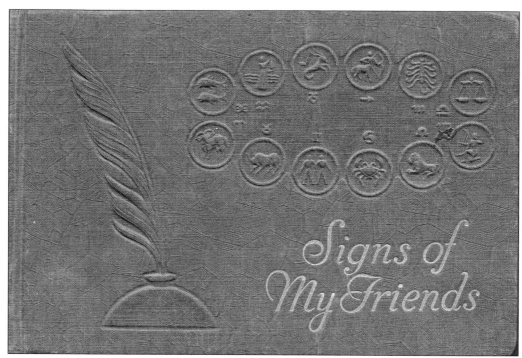

Irma Lawson requested visitors sign in during their stay at the Lawson Hotel in a book titled *Signs of My Friends*. Her personal friend Lionel Hampton signed the visitor book. Other prominent jazz musicians lodged there, including Lester Young, Rahsaan Roland Kirk, and Duke Ellington. Lionel Hampton stated in a May 1954 Pittsburgh news article, "Irma Lawson is more than a friend of mine, for she is responsible for the close relationship that has grown between my buddy, Father Bernard Strange of St. Rita's parish in Indianapolis and me. Irma is an illustrious person and an honored friend." (Both, courtesy of the estate and family of Irma Lawson.)

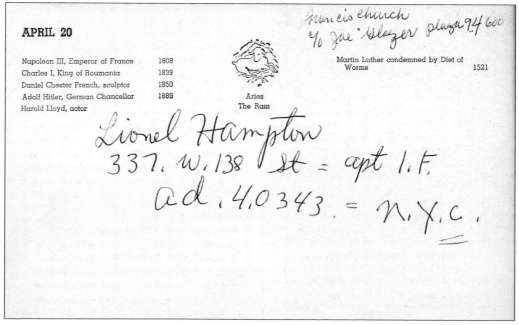

APRIL 20

Napoleon III, Emperor of France	1808	
Charles I, King of Roumania	1839	
Daniel Chester French, sculptor	1850	
Adolf Hitler, German Chancellor	1889	
Harold Lloyd, actor		

Aries
The Ram

Martin Luther condemned by Diet of Worms 1521

Francis church
% Joe Glazer plaza 9-4 600

Lionel Hampton
337. W. 138 St = apt 1.F.
Ad. 4.0343 = N.Y.C.

The 1940 edition of *The Negro Motorist Green-Book* contains an advertisement for Wilmington's Burton's Barber Shop at Eighth and Walnut Streets. Victor Hugo Green was a businessman and founder of the *Green Book*, which was published for Black motorists from 1936 to 1966 during the Jim Crow era. This travel guide provided advice on where Blacks could go to rest, dine, and socialize without dealing with racism resulting from prejudice and legal discrimination during segregation. The book was produced annually and mapped Black-owned businesses, including restaurants, barbershops and hair salons, nightclubs, hotels, and other establishments of Black life in cities across the nation. (Author's collection.)

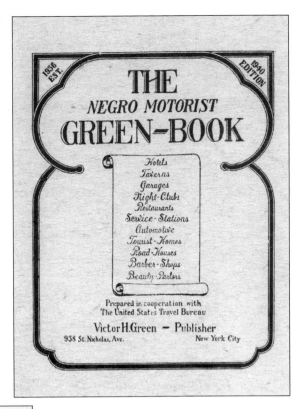

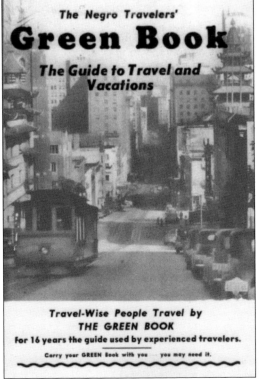

The 1954 edition of *The Negro Travelers' Green Book* includes an advertisement for the Lawson Hotel at Second and Poplar Streets. Although pervasive racial discrimination and poverty limited Black car ownership, as an emerging Black middle class bought automobiles, they faced a variety of dangers and inconveniences along the road—from refusal of food and lodging to arbitrary arrest. Instead of traveling on country roads and back roads where there was fear and uncertainty about what could happen to them, traveling interstates made for a safer route to their destination. *The Negro Travelers' Green Book* was a testimony of Black entrepreneurship, self-sufficiency, and progress. (Author's collection.)

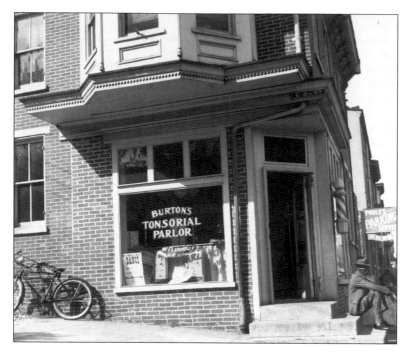

Burton's Tonsorial Parlor, pictured here around 1939, was located at 801 Walnut Street. Listed in the 1940 *Negro Motorist Green-Book*, it welcomed both local residents and out-of-town travelers to stop by for a haircut. (Courtesy of the Delaware Historical Society.)

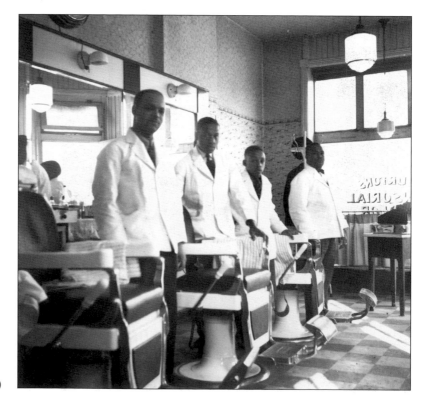

This March 1939 photograph shows four barbers standing at their chairs inside Burton's Tonsorial Parlor. (Courtesy of the Delaware Historical Society.)

Hermenia E. Garrett moved to Wilmington in 1968 and resided at 516 East Tenth Street. Garrett was founder and director of the Mount Carmel Day Care Center. Recognized for her tireless community activism in Wilmington, Garrett received a city council citation acknowledging her 35 years of service and leadership to civic and educational institutions. Garrett said in 1985, "I will expend whatever energy is required to get a job or task completed." (Courtesy of Lynn Faulkner.)

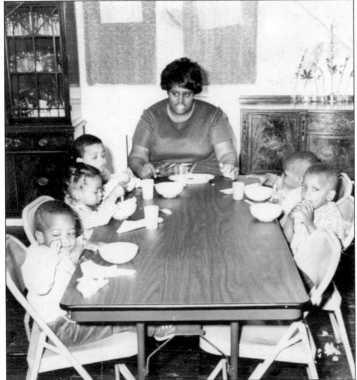

The Mount Carmel Day Care Center operated for over seven years, from 1968 to 1975, and served nearly 300 children at its peak. (Courtesy of Lynn Faulkner.)

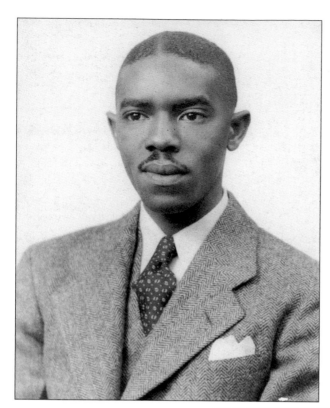

Harry S. Thomas, pictured here in the late 1920s, was owner of Champion Shoe Repair at Tenth and Walnut Streets. He started his business after serving in the armed forces. He developed a reputation as an excellent shoe repairman, providing high-quality service to local residents and frequent patrons from Pennsylvania. Thomas served the East Side community for decades with his wife, Thelma. They were members of Bethel AME Church. (Courtesy of Cheryl Burgess.)

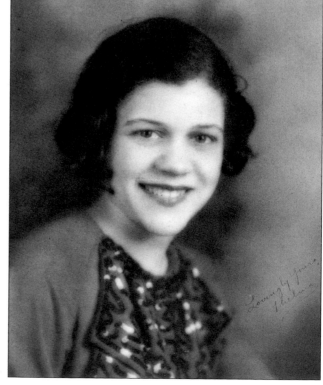

Thelma Thomas, affectionately known as "Honey Bunch," was the wife of Harry S. Thomas and worked with her husband at Champion Shoe Repair where she assisted with taking customer calls and managing shoe repair orders. She is pictured here around the late 1920s. (Courtesy of Cheryl Burgess.)

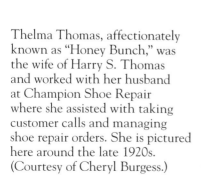

Charles Johnson (left) was owner of Johnson's Liquor Store at 528 Lombard Street. He is shown behind the counter shaking hands with an unidentified person around 1940. (Courtesy of the Delaware Historical Society.)

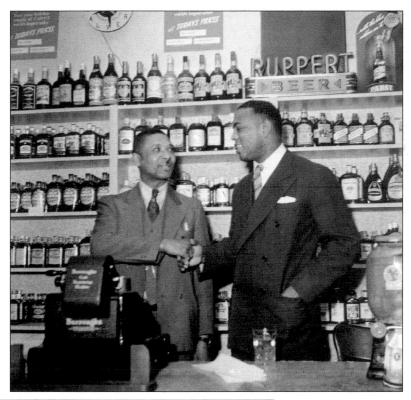

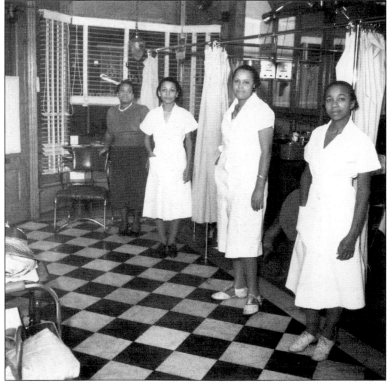

Hair stylists pose at Estella's Beauty Salon in April 1939. (Courtesy of the Delaware Historical Society.)

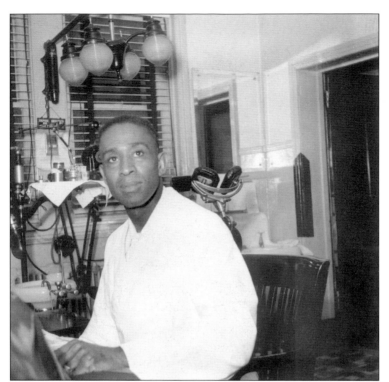

Dr. David Giles, dentist, is sitting in his office at 858 Poplar Street in 1940. (Courtesy of the Delaware Historical Society.)

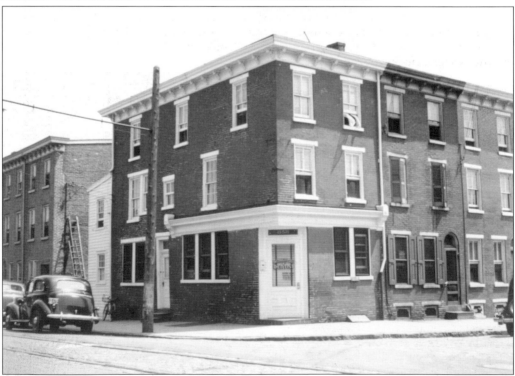

This c. 1938 photograph shows Dr. David Giles's dental office at 858 Poplar Street. (Courtesy of the Delaware Historical Society.)

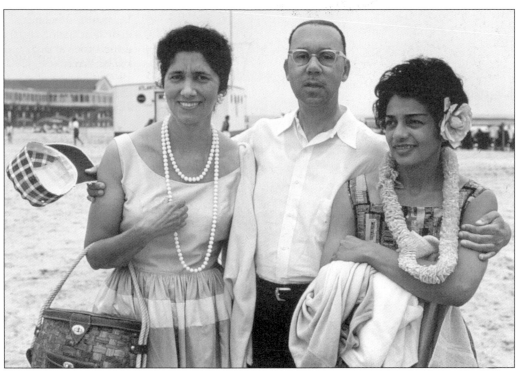

Dr. Leon V. Anderson (center); his wife, Beulah (left); and Louise S. Hopkins are pictured in the 1950s at a beach. Dr. Anderson was a medical doctor with an office at 826 Poplar Street. Anderson was also a community activist and worked with Thurgood Marshall to argue before the Supreme Court regarding school segregation. (Photograph by John O. Hopkins Jr.; courtesy of Lynn Nzingha Hopkins-Collins.)

Dr. Samuel G. Elbert Jr. and his wife, Nina, are pictured in the 1950s enjoying a day in the sun. Elbert was a medical doctor with an office at 928 French Street. His father, Dr. Samuel G, Elbert Sr. (1865–1939), was one of the first African Americans to open a medical practice in Delaware to serve Blacks. Originally from Chestertown, Maryland, Dr. Elbert Sr. was a prominent community leader in Wilmington. (Photograph by John O. Hopkins Jr.; courtesy of Lynn Nzingha Hopkins-Collins.)

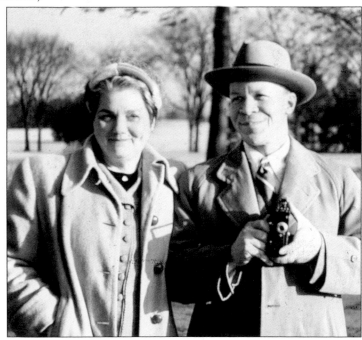

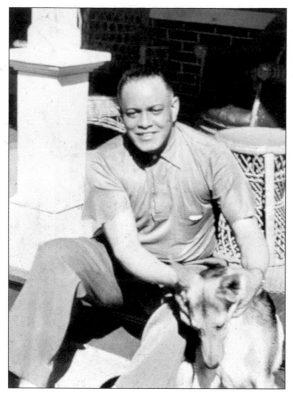

Dr. A. Roland Milburn, pharmacist, is pictured in the 1950s at home with his dog. Milburn was a graduate of Howard University and the Philadelphia College of Pharmacy. Active in civic and political affairs in Wilmington, Milburn chaired the Walnut Street YMCA membership drive and served as treasurer of the Wilmington City Republican organization. According to The Commissioners, a Philadelphia-based African American men's social club, Milburn's wife was the sister-in-law of the world-renowned American contralto Marian Anderson. (Photograph by John O. Hopkins Sr.; courtesy of Lynn Nzingha Hopkins-Collins.)

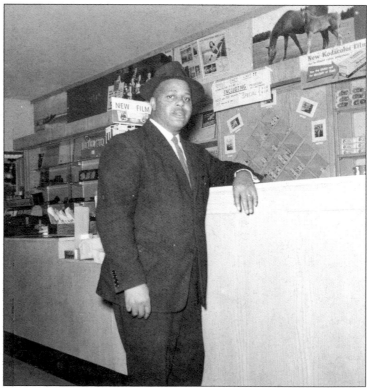

Dr. B. Napoleon Gupton is pictured standing at the counter at Milburn's Pharmacy at 922 French Street. (Courtesy of Judith Gupton-Wiley.)

L.E. Gaines, who owned and operated Gaines Barber, is standing inside his barbershop at 1022 Walnut Street. (Courtesy of the Delaware Historical Society.)

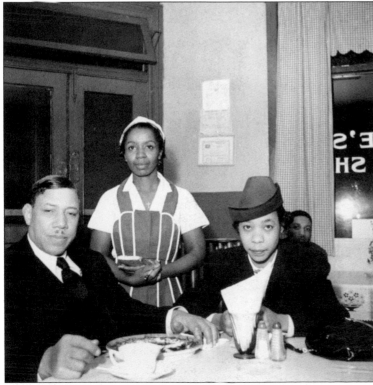

A woman identified only as Elsie, pictured standing between two patrons, was owner of Elsie's Chicken Shack at 1200 Walnut Street in the 1940s. (Courtesy of the Delaware Historical Society.)

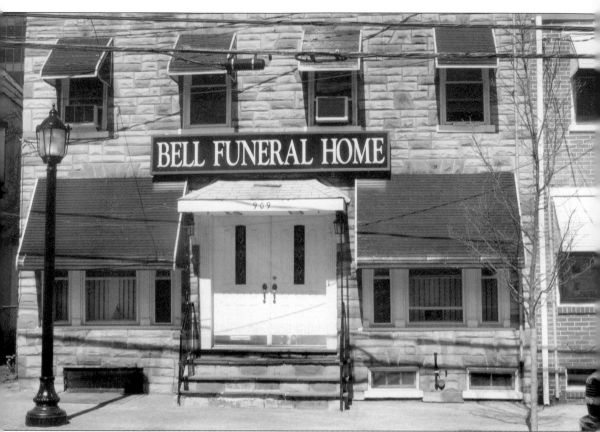

Bell Funeral Home was founded in the 1930s by Edward R. Bell at 909 Poplar Street (renamed Clifford Brown Walk). Professionally trained in mortuary studies, Bell became the first African American deputy coroner. The State of Delaware and Delaware Historical Society distinguished the funeral home as one of the oldest Black-owned businesses in Delaware. Passed down to three generations in the Bell family, James Llewellyn; his wife, Beverly Bell; and their children Kip and Kia continue to extend excellent, compassionate service to East Side residents and families across the city of Wilmington. (Courtesy of James Llewellyn and Beverly Bell.)

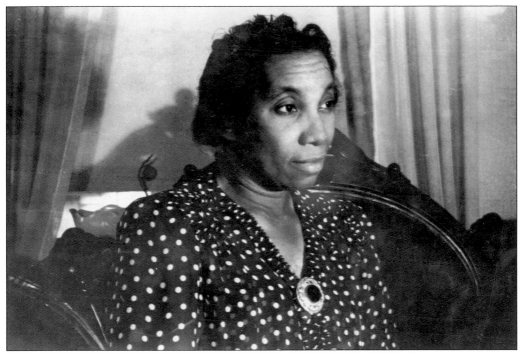

This is a 1950s photograph of Mary R. Gray, owner and operator of the Charles H. Gray Funeral Home. (Courtesy of Tanya Williams.)

Mary and Charles Gray lived at 722 North Walnut Street, the same location as Gray Funeral Home, pictured here in 1939. The Grays provided more than 20 years of service on the East Side and across Wilmington. During the early 20th century, many African Americans who owned funeral homes were known as "Negro Undertakers." The Grays were members of Bethel AME Church at 604 North Walnut Street. (Courtesy of the Delaware Historical Society.)

Luvenia Gray, wife of David Gray, is pictured here in the 1950s. (Courtesy of Tanya Williams.)

David Gray, husband of Luvenia Gray and son of Charles and Mary Gray, is pictured here in the 1950s. He was a photographer. (Courtesy of Tanya Williams.)

Dr. B. Napoleon Gupton, chiropodist, is pictured around 1947 standing on the front step of his medical office at 1012 North Walnut Street with Ernest Seldon, who was a teacher at Howard High School. (Courtesy of Judith Gupton-Wiley.)

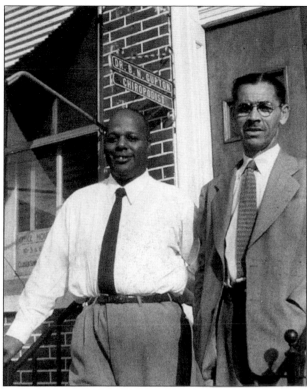

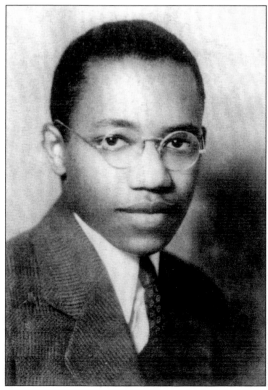

Pictured here around 1960, Dr. James W. Peaco Sr., a dentist, was a native of Havre de Grace, Maryland, and came to Wilmington as a teenager. Following graduation from Howard High School, Peaco attended Howard University and graduated with honors. He operated the practice at 1022–1024 Poplar Street for more than 30 years until his death on April 11, 1969. Dr. Peaco is honored in a mural at East Tenth Street as one of the East Side's prominent figures. (Courtesy of Doris P. Wiggins.)

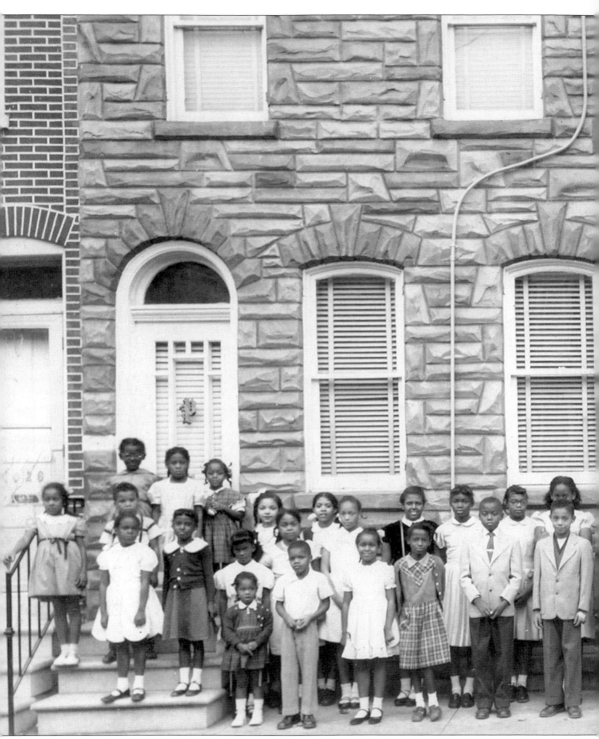

Neighborhood children gathered outside Dr. Peaco's dental office at 1022–1024 Poplar Street to celebrate siblings Joyce and James Peaco Jr.'s birthday party in 1949. James and Joyce, pictured

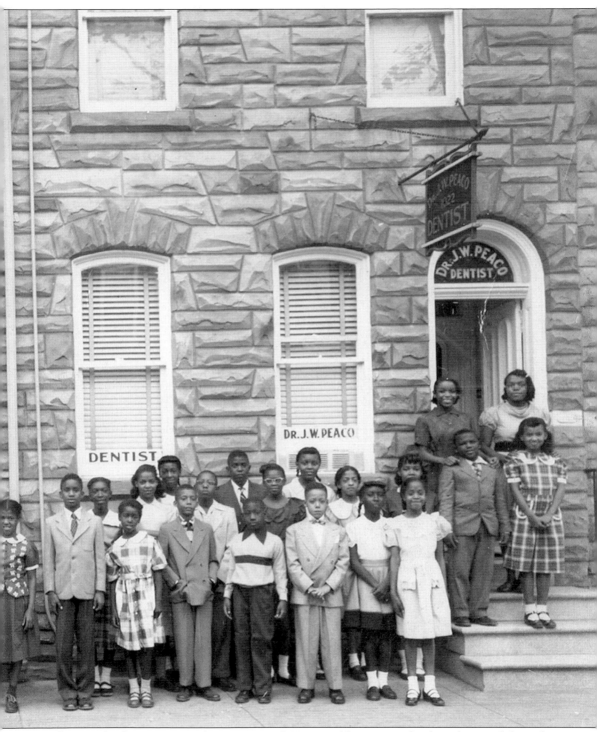

standing on the front step at right, were 10 and 11 years old, respectively; they always celebrated their birthdays together because they were born a week apart. (Courtesy of Doris P. Wiggins.)

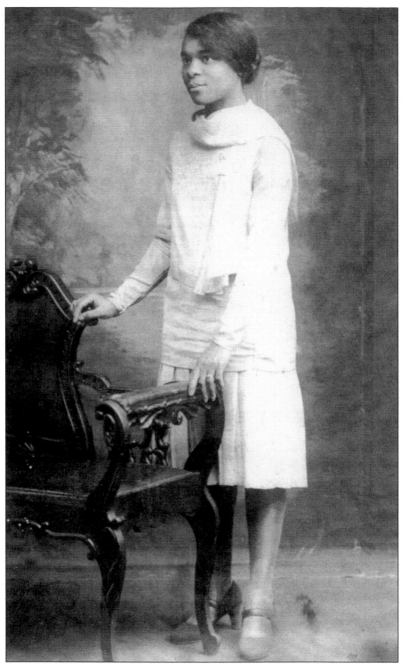

This 1930s portrait shows Rosa J. Petty-Gupton Peaco, the wife of Dr. Peaco. They lived at 1022 Poplar Street. She was a graduate of Howard High School and received her undergraduate education at Miner Teachers College and Delaware State College and her graduate education at the University of Delaware. She was a teacher for more than 40 years, which included teaching at Charles R. Drew Elementary School at Seventh and Lombard Streets. She was also an active member of Bethel AME Church, where she served on the trustee board, the Florida Grant Missionary Society, Stewardess Board No. 3, the Hostess Club, the Laymen's Organization, and the commission on membership and evangelism. (Courtesy of Doris P. Wiggins.)

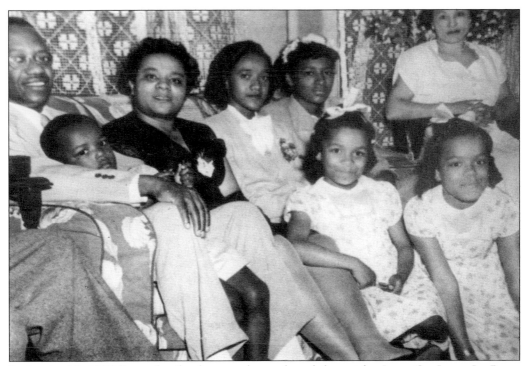

Posing in this 1946 Peaco family photograph are, from left to right, James Sr., James Jr., Rosa, Joyce, Doris, Dolores Dover, and Rosa's two young cousins. (Courtesy of Doris P. Wiggins.)

Stella Ewing moved to Wilmington from Maryland's Eastern Shore in 1937, graduating from Howard High School in 1948. A self-taught cook inspired by her mother, Lottie Johnson, Ewing opened the Knotty Pine Restaurant at 308 East Eleventh Street. Knotty Pine was given its name because of the pine walls that lined the interior of the restaurant. During the 1950s–1960s, the Knotty Pine became a safe haven for African Americans who were ostracized from white eating establishments. Ewing welcomed many local residents and well-known patrons to her restaurant as they gathered to discuss social issues, including Dr. Martin Luther King Jr., Ralph Abernathy, Cab Calloway, Chubby Checker, Clara Ward, the Five Blind Boys, James Brown, and Tina Turner. (Courtesy of Wanda Johnson, Esq.)

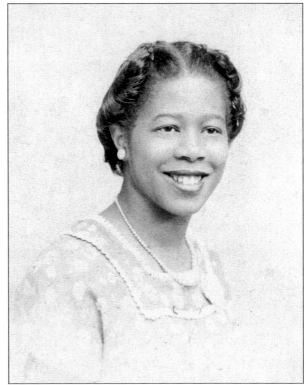

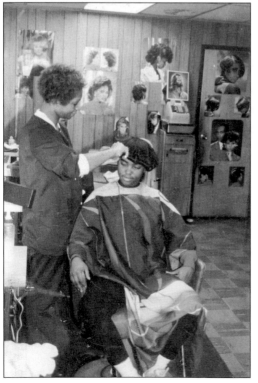

Lottie Johnson, shown here, inspired her daughter Stella to further the family's culinary abilities and to help start her mother's restaurant first known as the White Front Restaurant at Walnut and Taylor Streets. The restaurant later moved to East Eleventh street and was renamed the Knotty Pine. (Courtesy of Wanda Johnson, Esq.)

Maude Matthews, owner, manager, and hair stylist at Maude's Beauty Salon, is shown styling a patron's hair at the family-owned James and Jesse Barber Shop. (Courtesy of Maude Matthews.)

James Dendy Sr. was the owner of James and Jesse Barber Shop. It was established in 1959 and located at 719 East Tenth Street. (Courtesy of Maude Matthews.)

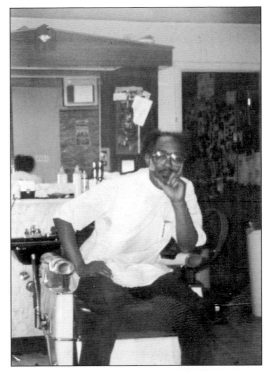

Jesse Dendy Sr. (right) was the other owner of James and Jesse Barber Shop. Richard Dendy is pictured giving a customer a shave. The shop relocated to 933 Bennett Street and was renamed in 1969 to James and Jesse's Barber Shop and Maude's Beauty Salon. (Courtesy of Maude Matthews.)

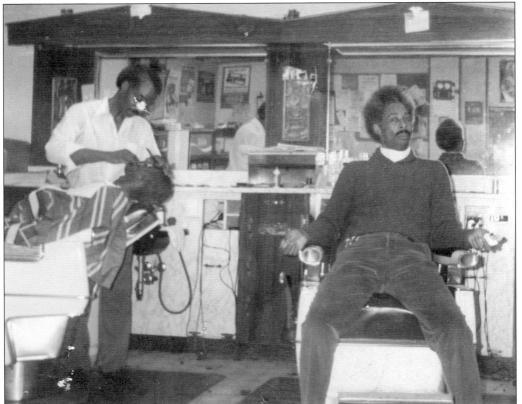

Among many historic structures erected on the East Side was the Samuel Newlin House at 423–425 French Street, built in 1838. (Courtesy of Special Collections, University of Delaware Library, Museums and Press.)

Three

HISTORIC CHURCHES AND RELIGIOUS CUSTOMS

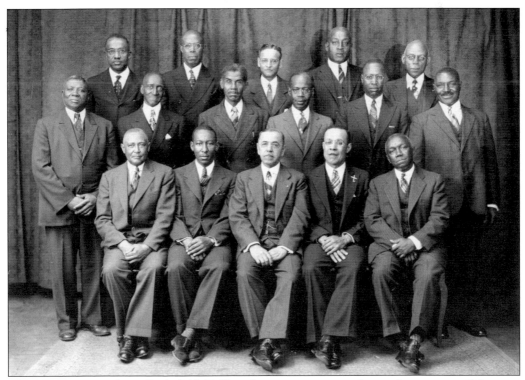

This 1930s portrait shows Bethel AME Church trustees, a group of men whose responsibility was to keep the operation of the church safe and attractive and ensure that the well-being and comfort of the edifice functions appropriately. On May 10, 1846, a group of African American residents of Wilmington who affiliated themselves with the African Methodist Episcopal Church held a meeting for the purpose of electing trustees and organizing as a corporate body. The congregation purchased land at Twelfth and Elizabeth Streets and built a new structure, which was dedicated in April 1847. (Courtesy of Bethel African Methodist Episcopal Church.)

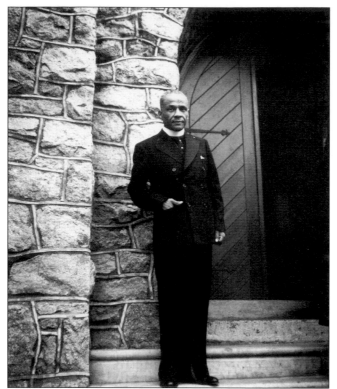

Rev. A. Chester Clark is standing on the front steps of Bethel AME Church in 1939. He served as pastor from 1933 to 1939. On January 1, 1935, a fire destroyed the beloved building. That same morning, trustees met with Reverend Clark and pledged that a greater Bethel would arise from the embers. Reverend Clark's courage and leadership allowed the congregation to rebuild. The surrounding community extended grace and compassion, granting the congregation permission to worship at Howard High School on East Twelfth Street and hold church meetings at Gray Funeral Home at Eighth and Walnut Streets. On March 5, 1937, members of the church dedicated their new house of worship at 604 North Walnut Street. (Courtesy of the Delaware Historical Society.)

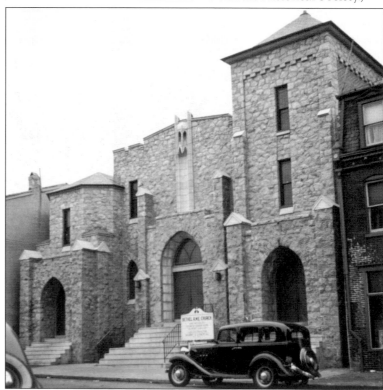

This 1939 photograph shows Bethel AME Church at 604 North Walnut Street. In 2021, the church celebrated its 176-year history. (Courtesy of Delaware Historical Society.)

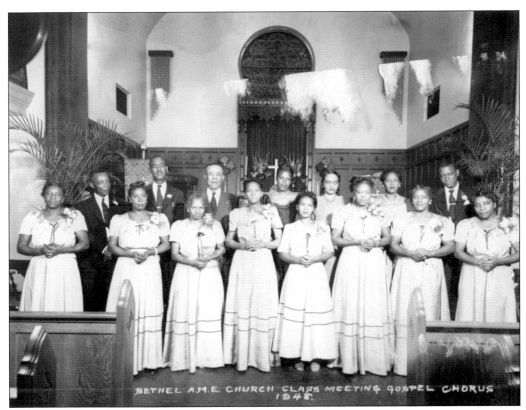

The Bethel AME Church gospel chorus is pictured in the sanctuary in 1948. (Courtesy of Bethel AME Church.)

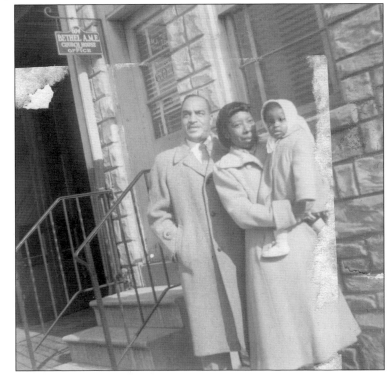

William Lewis is standing in front of the Bethel AME Church office with his expecting wife, Lennie, and daughter Marita in March 1957. (Courtesy of Marita Lewis.)

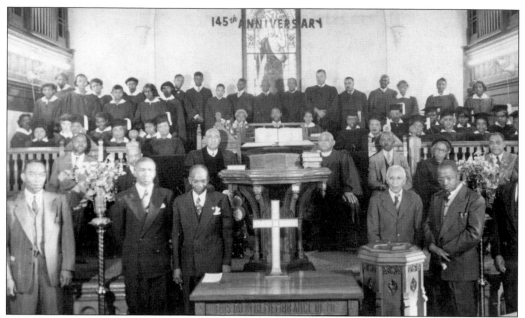

Members of Ezion–Mount Carmel United Methodist Church celebrate the church's 145th anniversary in 1950. In 1805, a group of African Americans desiring greater freedom of worship withdrew from Asbury Methodist Episcopal Church to form a separate congregation. Led by Peter Spencer and William Anderson, they established the African Methodist Episcopal Church at Ninth and French Streets. The original church was replaced by a new brick structure on the site in 1870, renamed Ezion Methodist Episcopal Church in 1885, and later rebuilt after a devastating fire. On February 14, 1971, the congregation of Mount Carmel Methodist Episcopal Church merged to form Ezion–Mount Carmel United Methodist Church. Today, the church celebrates over 216 years of service. (Courtesy of Ezion–Mount Carmel United Methodist Church.)

Pictured is an Ezion Methodist Episcopal Church youth class on Palm Sunday in 1961. (Courtesy of Carol Shockley.)

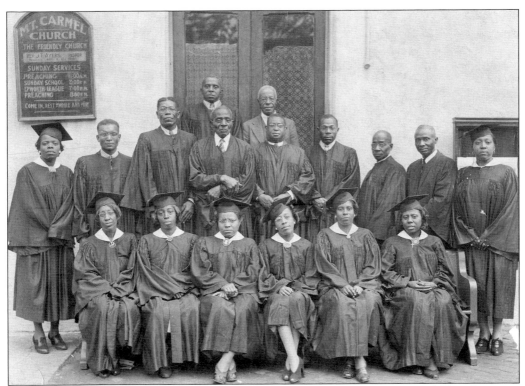

Members of the senior choir pose outside the Mount Carmel Methodist Episcopal Church around the 1930s. The church motto was "Come in, Rest Awhile and Pray." (Courtesy of William Majett Jr.)

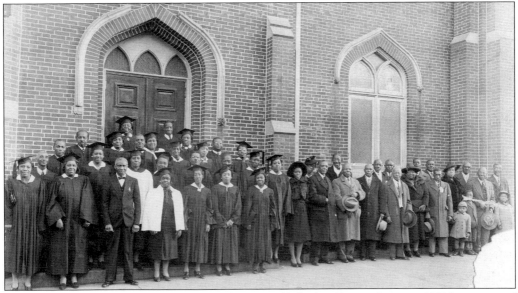

Mount Carmel Methodist Episcopal Church was established on Forrest Street in 1920 by a group of Wilmington residents who had migrated from lower Delaware. The congregation later moved to 504 East Eleventh Street, and in 1942, relocated again to 924 Lombard Street. Pictured here are choir members and church leaders outside the church on Lombard Street around the 1950s. The name Epworth Methodist Episcopal Church is engraved on the building. (Courtesy of William Majett Jr.)

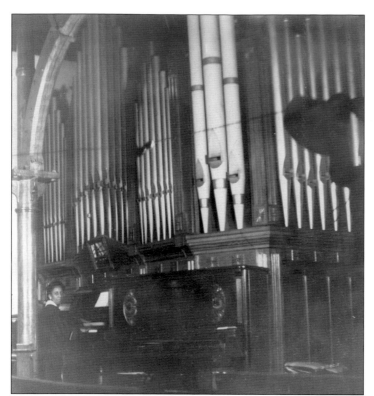

Ethel L. Majett is pictured around the 1930s sitting at the grand pipe organ inside the Mount Carmel Methodist Episcopal Church at 924 Lombard Street. (Courtesy of William Majett Jr.)

Mother African Union Methodist Protestant Church congregation members gathered with Edward R. Bell, a church trustee (center), at the parsonage around the 1950s. (Courtesy of Mother African Union Church.)

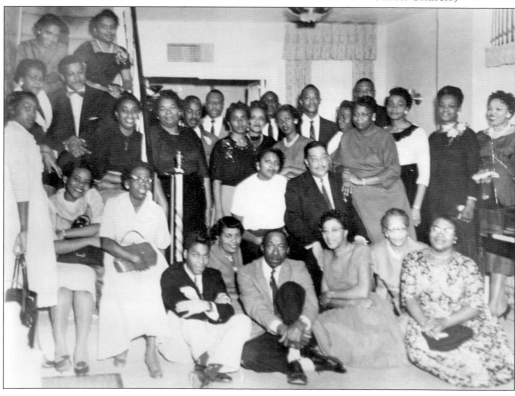

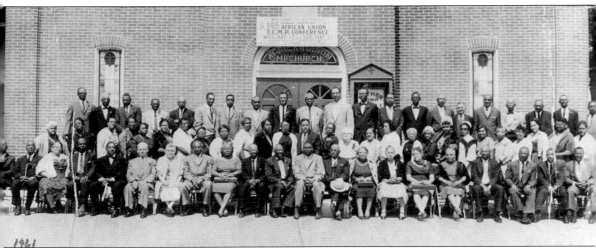

In 1961, congregational leaders and members of the Mother African Union Methodist Protestant Church are standing in front of the church on French Street between Seventh and Eighth Streets in recognition of the 148th quarterly conference of the African Union Methodist Protestant Church. The street has been renamed Peter Spencer Plaza. (Courtesy of Mother African Union Church.)

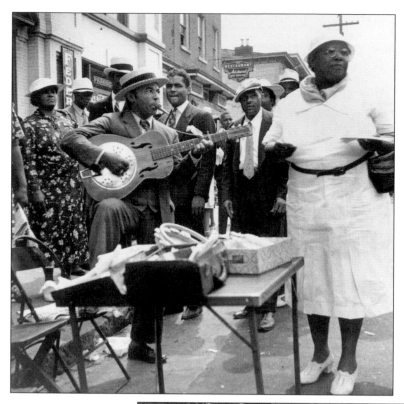

Pictured are people enjoying the sounds of praise that filled Wilmington streets during the big quarterly celebration on French Street on August 27, 1939. Known today as August Quarterly, this tradition has deep roots in African Union Methodism. Peter Spencer organized the first gathering in Wilmington in August 1813 shortly before the Union Church of Africans was incorporated. (Courtesy of the Delaware Historical Society.)

People are celebrating the gospel in song at the August Quarterly. Large tents were erected along French Street and at the rear of the Mother African Union Methodist Protestant Church to host congregational meetings, prayer, and revival services. Portable cook stoves to prepare food lined Eighth and Ninth Streets off French Street. (Courtesy of the Delaware Historical Society.)

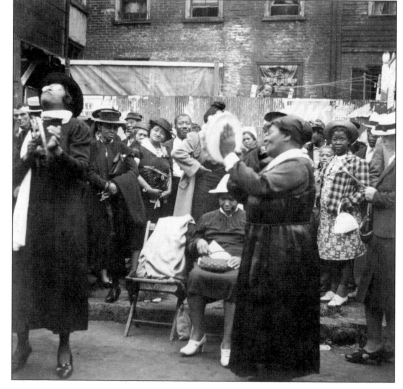

A member of
Mother African
Union Methodist
Protestant Church
recalled that slaves
from Centerville,
Maryland, were
given passes for
the day, and they
would come to the
August Quarterly
celebration in
wagons driven by
oxen. (Courtesy
of the Delaware
Historical Society.)

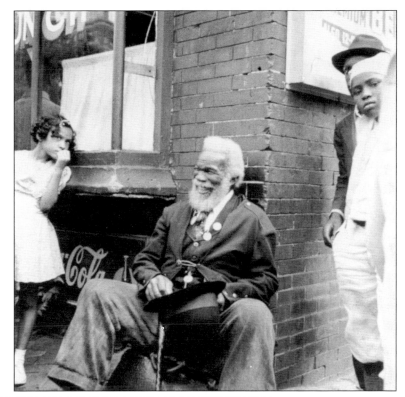

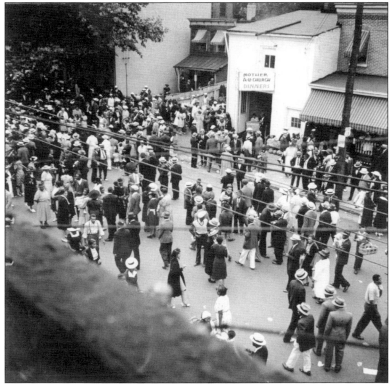

Crowds of
church members,
community
residents, and
visitors are
celebrating August
Quarterly in front
of Mother African
Union Church
where dinners were
sold to participants.
(Courtesy of
the Delaware
Historical Society.)

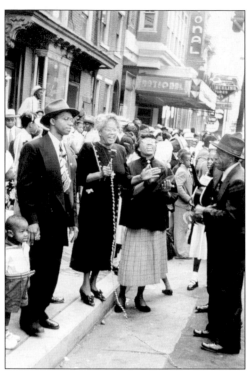

Around the 1940s, Wilmington residents gathered on French Street near the National Theatre, which was Wilmington's only Black-owned movie theater at the time, owned by John O. Hopkins Sr. (Courtesy of Lynn Nzingha Hopkins-Collins.)

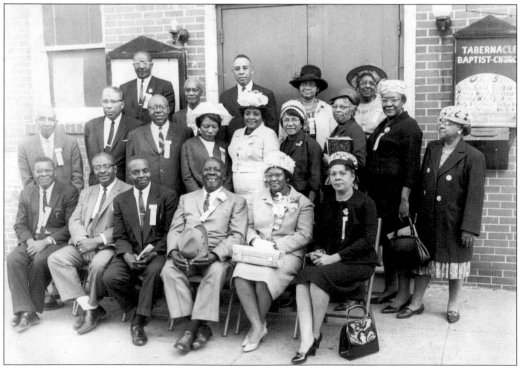

Reverend Wildler (second row, far left) and Reverend Majett (second row, third from left) joined with other church leaders in front of Tabernacle Baptist Church in celebration of a church convention in the 1950s. (Courtesy of William Majett Jr.)

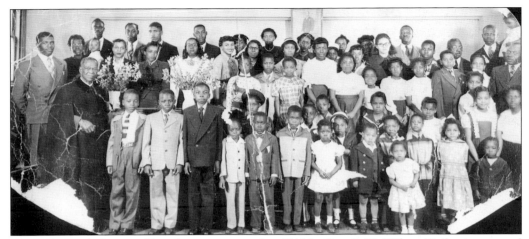

The Tabernacle Baptist Church was organized in 1919 by Rev. R.H. Wilson. Following several church relocations, this photograph shows families, children, and church leaders posing in their edifice at 504 East Eleventh Street in the 1960s. Renamed Tabernacle Full Gospel Baptist Church, in 2021, the church celebrates 102 years of service. (Courtesy of Tabernacle Full Gospel Baptist Church.)

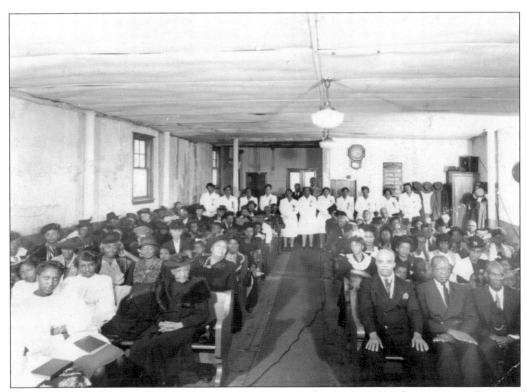

The Tabernacle Baptist Church congregation is pictured attending Sunday service at 504 East Eleventh Street in the 1950s. (Courtesy of Tabernacle Full Gospel Baptist Church.)

March 7, 1938.

The Chorus met on the above date for their regular business meeting. The meeting was opened by singing Jesus Keep me near the Cross. Prayer by Deacon Roberts. Sis. Roberts acting Pres. for the evening. The minutes was then called for and read. It was moved and second the minutes be received and adopted. It was moved and second the committee's report on gowns be received, & committee discharged. It was suggested a supper be held at the home of Sis. Hunter. c. 8 Mr donations Sis. Fry, Pig feet. Sis. Wilson and Sis. Roberts Pig feet. Sis. Wilson sweet potato pie. Sis. Cuff sugar Bro. Billings peanuts. Sis. Waters and Sis. Fry Potato Salad. It was left to Sis. Fry to get Palm for Palm Sunday. It was moved and second we have a dinner at the Church the 1st. Sun. in April. Menu. Chicken, fish, ham, Ice Cream, cake, Root Beer. It was suggested we have a Pagent. the first Sun. night in April. Sis. Roberts to intercede in getting The Holy City Chorus. Dues.19 leaving in treas. $6.47. By laws were tabled. The meeting adjourned until first monday in April. Meeting closed by our advisor Deacon Roberts by singing God be with you till we meet again.

This Tabernacle Baptist Church ledger is dated March 7, 1938. During the early 20th century, many African American houses of worship kept church ledgers, often written in script or cursive writing, to record information such as meeting minutes, financial records, and other matters for historical archives. (Courtesy of Tabernacle Full Gospel Baptist Church.)

Bishop Aretha Morton, senior pastor of Tabernacle Baptist Church (renamed Tabernacle Full Gospel Baptist Church) and a native of Wilmington, resided at 406 East Tenth Street for 65 years. Bishop Morton recalled the influence of her grandmother Ethel Clark Jackson, who was a longtime teacher in Delaware, and other educators who lived on her block, commonly known as "teachers' row." Morton is regarded as a local historian of the East Side. A graduate of Howard High School, she later received her license in 1959—a break from tradition and Baptist Church protocols—and became the first female to pastor a Baptist church in the state of Delaware. In 1983, she accepted the call to pastor Tabernacle Baptist Church. (Courtesy of Tabernacle Full Gospel Baptist Church.)

Pictured is Scott AME Zion Church at 629 East Seventh Street. The church was erected in 1852 and operated as an interdenominational education facility known as the Seventh Street Sabbath School. The name changed to honor pioneering Methodist bishop Levi Scott. Scott AME was regarded for its outstanding Lawson singing groups—in honor of Rev. L.A. Lawson, who ministered there for 23 years. The church continues its work in the community as it has for over 165 years of devoted ministry. (Courtesy of the Delaware Historical Society.)

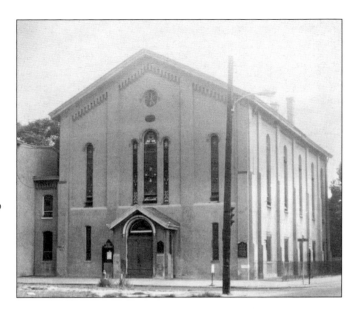

St. Joseph Catholic Church was established on December 30, 1889, under the leadership of Fr. John A. DeRuyter of the Josephites. Located at 1012 North French Street, the church's central mission at the time was to improve the lives of people of color and provide comfort and support, as well as Christian education for the children. Incorporated as St. Joseph's Society for Colored Missions in 1890, its ministry included an orphanage, school, and a free dispensary. In 2021, St. Joseph Catholic Church celebrated over 132 years of service. (Courtesy of St. Joseph Catholic Church.)

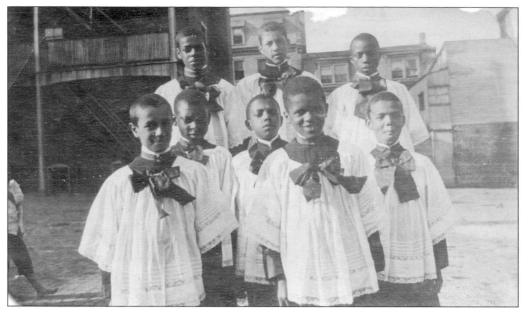

St. Joseph orphan boys are dressed as altar servers to assist the priest during Mass in the late 1930s. In 1892, St. Joseph Catholic Church built an orphanage for homeless Black boys in response to a growing need for housing orphan children. The orphanage grew to over 200 boys who grew up under the St. Franciscan doctrine. Sixteen Franciscan nuns taught and cared for the boys, affectionately known as "Home Boys" by the St. Joseph parishioners. (Courtesy of St. Joseph Catholic Church.)

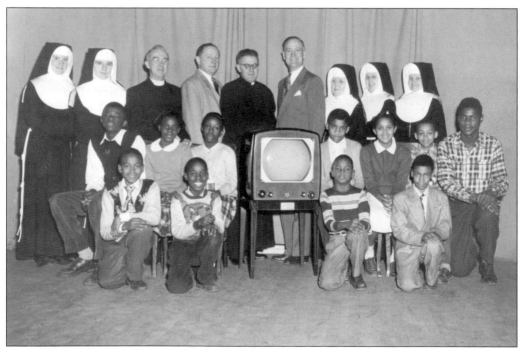

This c. 1950s photograph displays a new television gifted to the church for orphanage children to watch. (Courtesy of St. Joseph Catholic Church.)

Pictured around the 1950s are Daniel and Ethel Lewis resting out back. They were employed at St. Joseph Catholic Church as a caretaker and a cook, respectively. (Courtesy of St. Joseph Catholic Church.)

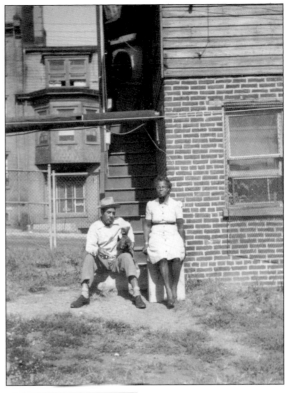

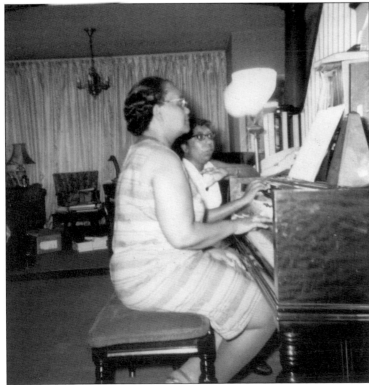

Lennie Lewis is giving piano lessons to a student in this 1950s photograph. Lewis was church organist for the Old Swedes Church of Trinity Episcopal Parish for 27 years. Professionally trained in classical music at Fisk University and the Julliard School of Music in New York, she provided organ accompaniment at St. Joseph Catholic Church, Ezion Methodist Episcopal Church, Mount Carmel Methodist Episcopal Church, and Bethel AME Church during summer vacations and other occasions. (Courtesy of Marita Lewis.)

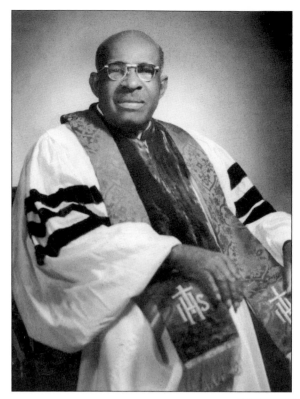

Right Rev. John P. Predow was the oldest Union American Methodist Episcopal bishop in the UAME General Conference. Predow was born and raised at 516 East Tenth Street. He served as minister in the denomination for 54 years and as bishop from 1966 until his retirement in 1974. He was overseer and presiding bishop for Wilmington, which included St. Paul UAME Church and Mother UAME Church at 1206 French Street. He was also head of the first, second, third, and fourth Episcopal districts. Predow envisioned bringing back sections of Wilmington that were experiencing decline. His vision resulted in development of the Boulden Academy and Seminary, which opened in 1967. He also opened the church-sponsored Predow Apartments, a 72-unit residential property. Bishop Predow was a graduate of Lincoln University, Pennsylvania, and the Philadelphia Bible Institute. (Courtesy of Lynn Faulkner.)

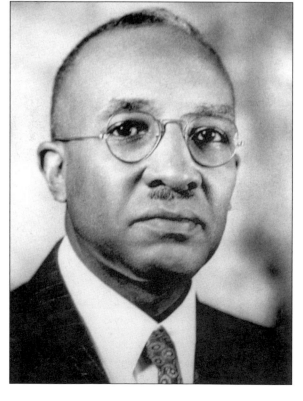

Rev. Arthur R. James founded Central Baptist Church at 839 North Pine Street in 1943. It was established on the belief that the church is a place to uplift families and serve as a meeting spot for community organizations. The name signifies that God's glory is alive in a central area of Wilmington's East Side. In 2021, Central Baptist Church celebrated 78 years of service. (Courtesy of Central Baptist Church.)

Four

NEIGHBORHOOD
SCHOOLS AND EDUCATORS

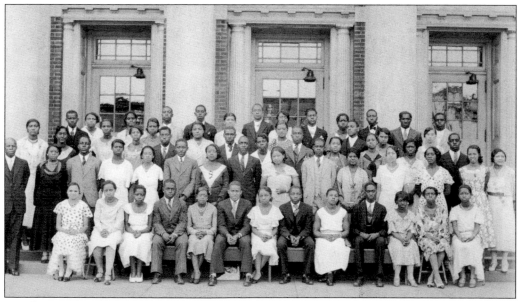

Members of the Howard High School class of 1932 stand outside the school. Howard High School was designated as a national landmark in 2005 because of its role and historic significance in the 1954 *Brown v. Board of Education* case, which struck down the "separate but equal" doctrine, ending segregation in public schools. Howard graduate Louis Redding was among a team of lawyers led by Thurgood Marshall who won the case. (Courtesy of the Delaware Historical Society.)

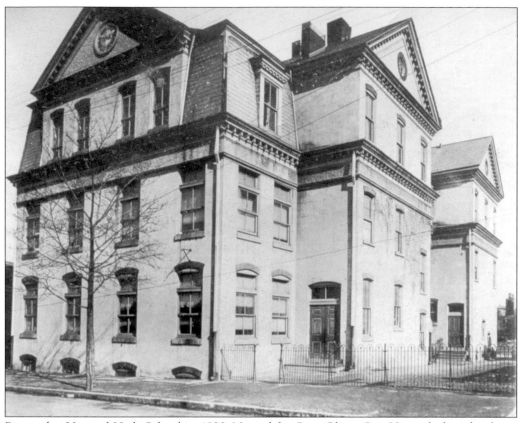

Pictured is Howard High School in 1920. Named for Gen. Oliver Otis Howard, the school was established in 1867. General Howard was commissioner of the Freedmen's Bureau and sought to improve Black education with educator and principal Edwina Kruse. Black residents of Delaware's New Castle, Kent, and Sussex Counties had to attend Howard if they wished to complete high school during segregation. (Courtesy of the Delaware Historical Society.)

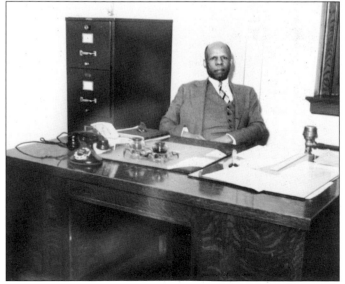

George A. Johnson, shown here around 1940, began his 35-year career as principal of Howard High School in 1924 and retired in 1959. (Courtesy of the Delaware Historical Society.)

Joe Anderson Morris, pictured here around 1940, was Howard High School's first business education instructor and spent 48 years in the Wilmington public school system. He was a community leader, an active Republican, a notary public, the first Black to be appointed to the Alcohol and Beverage Control Commission, the first Black to be appointed to the Board of Public Works, and the first Black to be appointed as a magistrate. He was also a life member of the NAACP and a member of Gamma Theta Lambda chapter of Alpha Phi Alpha fraternity in April 1952, serving as the chapter's president in 1964. (Courtesy of the Delaware Historical Society.)

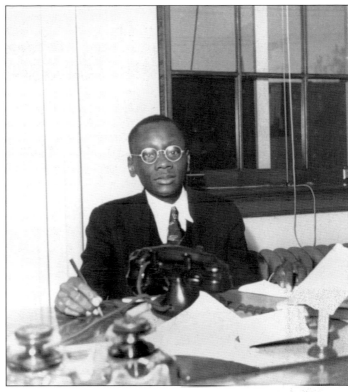

William Branch was a history teacher at Howard High School in the 1950s. (Courtesy of Cynthia Elliott-Oates.)

Leroy Griffin attended Howard High School among many students who attended segregated schools in Delaware. In fact, the class of 1953 was one of the last segregated classes at Howard High resulting from the 1954 ruling which overturned *Plessy v. Ferguson* and declared state laws establishing separate public schools for Black and White students to be unconstitutional. (Courtesy of Cynthia Elliott-Oates.)

Gertrude Redding was a member of the Howard High School class of 1953. She was very outgoing and loved to dance. She formed a modern dance club comprised of friends from school and performed dance routines. Redding grew up to become a physical education teacher in the Wilmington public school system. (Courtesy of Cynthia Elliott-Oates.)

Lloyd S. Casson was a member of the Howard High School class of 1952. He served in the US Army, and upon completion of military service graduated with a bachelor of arts degree from the University of Delaware and master and doctorate of divinity degrees from the Virginia Theological Seminary. Father Casson was the first rector of Episcopal Church of Saints Andrew and Matthew in Wilmington. After serving over 43 years in the Episcopal Church, Casson is currently rector emeritus of Saints Andrew and Matthew. (Courtesy of Cynthia Elliott-Oates.)

Wilbert "Bunny" Miller was a member of the Howard High School class of 1955. Among his many accomplishments, Miller was a former principal of P.S. DuPont High School and a member of the Delaware State University Sports Hall of Fame for baseball. (Courtesy of Cynthia Elliott-Oates.)

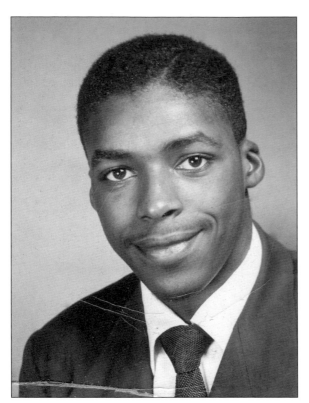

William Taylor was a member of the Howard High School class of 1953. He was academically astute as well as an athlete who played on the football team. Following graduation, Taylor worked for the DuPont company. (Courtesy of Cynthia Elliott-Oates.)

Charles "Chuck" Griffin was a member of the Howard High School class of 1953. Griffin was Delaware's first Black police chief, appointed to the Town of Delaware City police force in 1971. His appointment by Mayor Philip Cruchley was described as a milestone of racial equality in a 1971 *News Journal* article. (Courtesy of Cynthia Elliott-Oates.)

Butch Lewis attended Howard High School in the 1950s. Students at that time were a close-knit group who took interest in each other and engaged in activities together while in school. (Courtesy of Cynthia Elliott-Oates.)

Charles Stewart was a member of the Howard High School class of 1953. He was an exceptional basketball and baseball player. (Courtesy of Cynthia Elliott-Oates.)

Shirley Lewis was a member of the Howard High School class of 1953. Bernard Pinkett, who served as the class president, led activities that brought classmates together years after graduation, meeting for informal events and annual class reunions and ensuring that everyone maintained a relationship among one another. (Courtesy of Cynthia Elliott-Oates.)

Yvonne (Keys) Burgess was a member of the Howard High School class of 1953. She was an outstanding student academically. She and her sisters Delores and Betty were wonderful opera singers. An active member of Bethel AME Church, she played the church piano. (Courtesy of Cynthia Elliott-Oates.)

Walter Parker was a member of the Howard High School class of 1953. Many classmates in the class of 1953 who attended college tested out of freshman English courses due to the advanced instruction they received in Pauline Young's English department at Howard High. (Courtesy of Cynthia Elliott-Oates.)

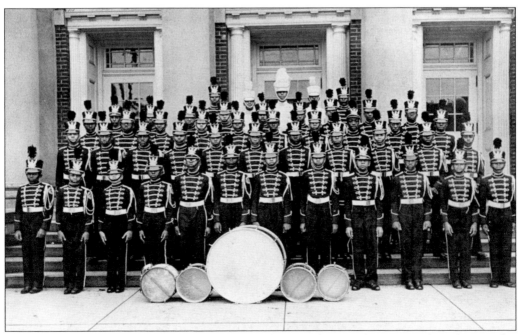

Pictured is the Howard High School band. The date is unknown. (Courtesy of Sandra Wright, chair of Howard High School Alumni Preservation Committee.)

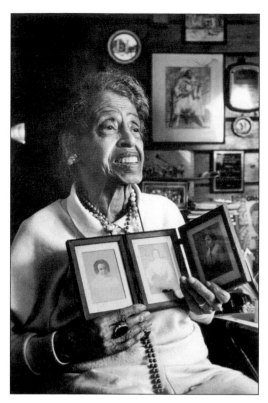

Pauline A. Young (1900–1991) was a teacher, librarian, community activist, preservationist, writer, and researcher of Delaware's Black history. Young resided at 916 French Street and attended kindergarten through high school at Howard School. She matriculated at the University of Pennsylvania and Columbia University, where she earned a graduate degree in library science. Young led the establishment of Howard High's first-ever library. Her aunt, Alice Dunbar-Nelson, introduced a young Pauline to many prominent figures, including Paul Robeson, William E.B. DuBois, and Langston Hughes. (Courtesy of Sandra Wright, chair of Howard High School Alumni Preservation Committee.)

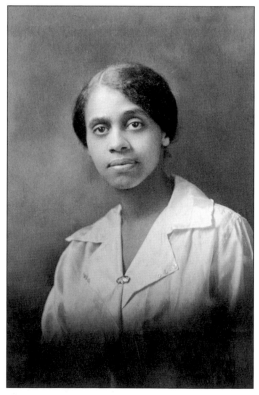

Lelia Moore Young, pictured around 1929, resided at 916 French Street and was a teacher at Howard High School. She was Pauline A. Young's sister. (Courtesy of Special Collections, University of Delaware Library, Museums and Press.)

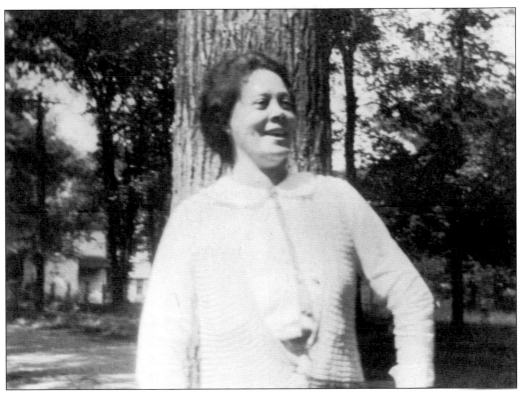

Alice Dunbar-Nelson (1875–1935) was a poet, English teacher, community and political activist, journalist, lecturer, author, and poet. She resided at 916 French Street and 1310 French Street. A graduate of Straight College (now Dillard University) and Cornell University, she became a teacher at Howard High School and married Paul Laurence Dunbar. Her books include *The Goodness of St. Rocque and Other Stories* and *Violets and Other Tales*. Dunbar-Nelson also wrote an unpublished manuscript entitled *This Lofty Oak* about the life of Edwina B. Kruse, principal at Howard High School. (Courtesy of Special Collections, University of Delaware Library, Museums and Press.)

NOTICE!!
Mrs. Paul Laurence Dunbar
COMING!

Mrs. ALICE DUNBAR-NELSON of Wilmington, Del., formerly the widow of the Greatest Negro Poet, Paul Laurence Dunbar

~Will Lecture At~

THIRD BAPT. CHURCH
FRIDAY, OCT. 7
7:30 P. M.

As a great Lecturer and journalist, Mrs. Dunbar-Nelson is one of the outstanding characters of the day. She is certainly well known in the Literary World throughout the length and breadth of this country. Her name was among the few that was broadcasted over the Radio Sept. 12, when Mrs Ruth Dennis stepped before a broadcasting station and made a speech on "SOME NOTABLE COLORED WOMEN." She is attractive in Features and in appearance.

This is Mrs. Dunbar's first visit to Portsmouth and she says: "I can give you an 'Evening with Dunbar."

The lecture will be illustrated with Readings from the poet. The program will be interspersed with Music by the Choir. All are invited to attend.

Admission, 25 cents
DR. B. W. DANCE, PASTOR

Somerville Printery, 812 Columbia Street.

This c. 1929 public notice announced Alice Dunbar-Nelson's speaking engagement at Third Baptist Church in Portsmouth, Virginia. (Courtesy of the Delaware Historical Society.)

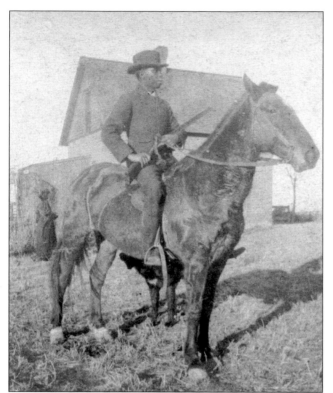

Paul Lawrence Dunbar (1872–1906) was a renowned poet, novelist, and author. He was regarded as one of the leading African American writers of the 20th century. His extensive body of work includes *Oak and Ivy* in 1893, *Majors and Minors* in 1896, and *Lyrics of Lowly Life*. Dunbar toured and delivered public readings around the United States. In 1897, he traveled to London to spend several months touring and reading in English literary circles. (Courtesy of Special Collections, University of Delaware Library, Museums and Press.)

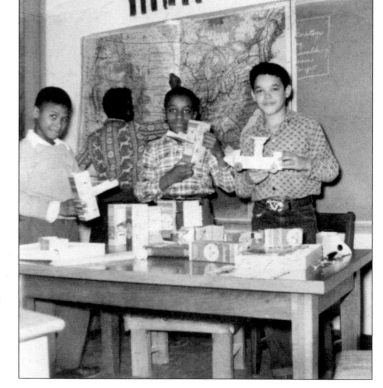

From left to right, sixth graders Jimmie Price, William "Bill" Majett, William Moore, and unidentified are enjoying class time in January 1955 at Frederick Douglass Stubbs Elementary School at 1100 North Pine Street. (Courtesy of William Majett Jr.)

Eldridge J. Waters was an educator, administrator, and the first Black male elementary school principal in Delaware. Waters served as principal of Frederick Douglass Stubbs Elementary School during the 1950s. He was a prolific writer, and in his 1957 journal article "Evaluating Progress toward Integration," he argued that in Wilmington the basic principles for planning an educational program were the same whether the school system was racially integrated or racially segregated. (Courtesy of the Delaware Historical Society.)

Maurice Pritchett was a Delaware educator, principal at the Bancroft School (1968–2008), community leader, and Howard High School basketball player. Pritchett was born and grew up on the East Side of Wilmington; received his secondary education at neighborhood public school Nos. 5, 29, and 20; and graduated from Howard High School. Pritchett graduated from Delaware State College (now Delaware State University) in 1965. Mentors such as Nathan "Doc" Hill of the Walnut Street YMCA and other community leaders helped shape Pritchett's success and passion for serving the East Side community. A recipient of many awards, Pritchett is a member of the Delaware State Basketball Hall of Fame and Delaware Afro-American Sports Hall of Fame. (Courtesy of Maurice and Juanita Pritchett.)

Ethelda "Ted" Jane Dean is standing in front of her house near Colespring, Delaware, where she was born, around 1938. She grew up at 512 East Ninth Street, graduated from Delaware State College, and was recognized with honors as a teacher's aide in math and English at the Bancroft School, where she taught for nearly 20 years. (Courtesy of Ron Dean.)

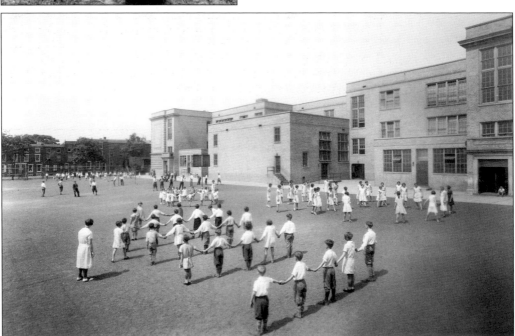

The Bancroft School, at 700 North Lombard Street, enrolled predominantly White students, as illustrated in this June 1931 photograph. As more African Americans migrated to Wilmington's East Side, Bancroft shifted to enrolling predominantly Black students and remains an institution that serves the educational needs of the East Side's Black population. (Courtesy of Delaware Historical Society.)

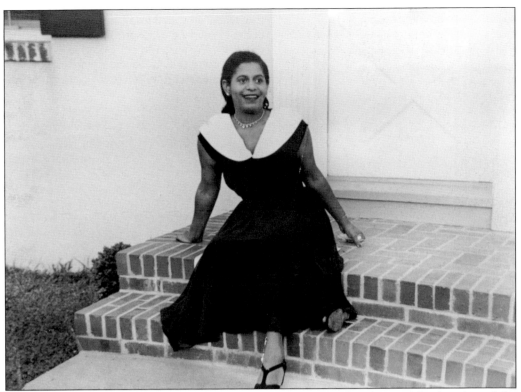

Pictured here around the 1950s, Kathryn Hazeur was a principal and one of the founders of the Drew Pyle School on the East Side. She was the first person of color accepted to the University of Delaware who majored in education. She later obtained her masters degree in education from Hampton University and took courses toward her doctoral degree at Columbia University. Hazeur was also a member of Alpha Kappa Alpha sorority. (Courtesy of August Hazeur.)

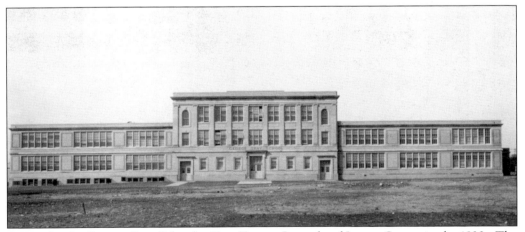

Pictured is the George Gray School at East Twenty-Second and Locust Streets in the 1930s. The original George Gray School opened in 1926 and was expanded in 1953. After years of sitting vacant, the school was rehabilitated and reopened in 2000 as the Thomas Edison Charter School. (Courtesy of the Delaware Historical Society.)

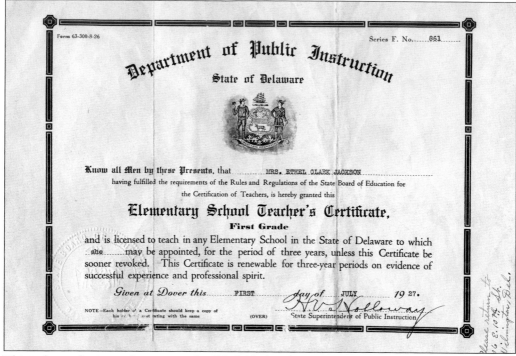

This is the teacher's certificate granted to Ethel Clark Jackson in July 1927. Jackson is the grandmother of Bishop Aretha Morton of Tabernacle Baptist Church. In the late 1880s, the state Board of Education instituted a first-ever examination of teacher certificates. The examination was designed to raise quality standards of teacher instruction, which included state colored schools in the late 1800s. Teachers were examined on the number of daily recitations, time devoted to each class, the number of classes in each branch, and methods of instruction. State appropriations were granted to colored schools in Delaware at the time. (Both, courtesy of Bishop Aretha Morton.)

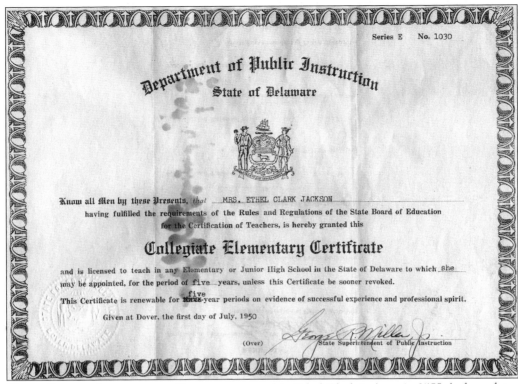

Series E No. 1030

Department of Public Instruction

State of Delaware

Know all Men by these Presents, *that* ___MRS. ETHEL CLARK JACKSON___

having fulfilled the requirements of the Rules and Regulations of the State Board of Education for the Certification of Teachers, is hereby granted this

Collegiate Elementary Certificate

and is licensed to teach in any Elementary or Junior High School in the State of Delaware to which _she_ may be appointed, for the period of _five_ years, unless this Certificate be sooner revoked.

This Certificate is renewable for _five_-year periods on evidence of successful experience and professional spirit.

Given at Dover, the first day of July, 1950

(Over) State Superintendent of Public Instruction

This collegiate elementary certificate was granted to Ethel Clark Jackson in 1955. Jackson later earned an elementary school teacher's certification and a certificate to teach junior high school. Her teaching career spanned more than 30 years. Jackson resided at 406 East Tenth Street. (Courtesy of Bishop Aretha Morton.)

Paul Loper was a Delaware educator and administrator for more than 40 years. He attended Frederick Douglass Stubbs Elementary School and graduated from Howard High School in 1963. Loper earned a scholarship to attend Delaware State College (now Delaware State University) and became the first African American paid student teacher at the time. Loper graduated in 1968. He resided at 1242 Wilson Street where his family lived for more than 30 years. He recalled that neighbors regarded his family as the "churchgoing Lopers," as they were dedicated members of St. Paul's UAME Church on East Eleventh Street. Loper had many mentors who shaped his life, including Eldridge Waters, Dr. Joseph Johnson, Dr. Crosby, and Clifton "Gator" Lewis. Raised by his grandmother Mary Lee Mando, Loper recalled her words of wisdom that she shared with him as a child: "If you don't have the sense you were born with, you're not going to do anything with it." (Courtesy of Paul and Faith Loper.)

St. Joseph Industrial School for Boys is shown in this 1950s photograph. The church established the St. Joseph Industrial School for Boys in 1894 for orphan boys to learn useful trades before entering the world at age 21. Over time, school integration and changing residential and economic patterns in the city of Wilmington caused enrollment to decline, and the school closed in 1956. (Courtesy of St. Joseph Catholic Church.)

This schoolhouse, known as School No. 1, was built on the corner of French and Sixth Streets in the 1800s, following passage of Delaware's legislation on the first organization of Wilmington's public schools. The school had two large rooms with 120 total seats. Subsequent state legislation organized a general public school system for the city of Wilmington. By 1859, seven schoolhouses were erected in Wilmington. Schools Nos. 2, 3, 5, 6, and 7 were used for primary grades, and Nos. 1 and 4 served higher grades. Residents on the East Side recalled neighborhood schools for Black students were Nos. 5, 9, 20, and 29. (Courtesy of the Delaware Historical Society.)

Five

ARTS, CULTURE, AND ENTERTAINMENT

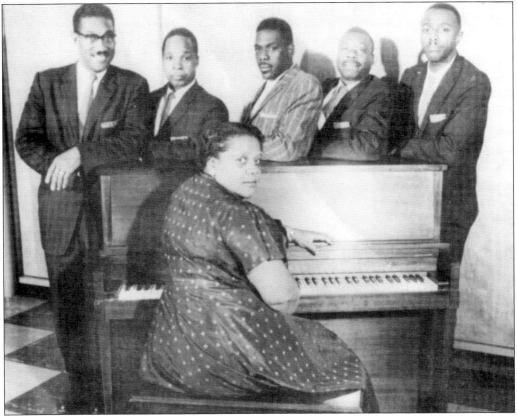

Queen Bell and Her Nobleman Band frequently performed at the Baby Grand on Ninth and Poplar Streets, the DuPont Hotel, the Wilmington Country Club, and occasionally with trumpeter Clifford Brown. Frances Bell, known as Queen Bell, is pictured sitting at the piano with her band members. From left to right are a Mr. Percy (trumpet), Elmer Gardner (drummer), Edward "Frency" Smith (lead vocalist), Wilson "Smitty" Smith Sr. (saxophonist), and Doug Holland (guitarist). (Courtesy of Tanya Williams and Ronald Smith.)

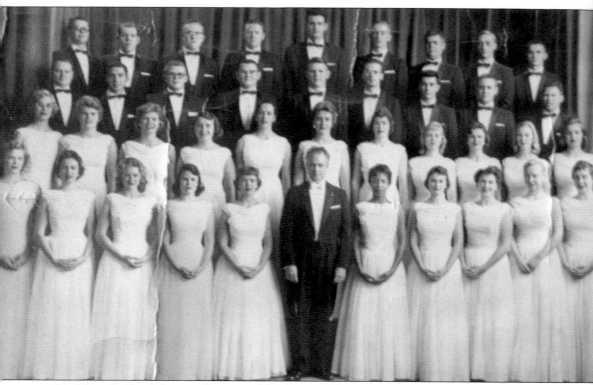

Madeline Bolden-Johnson (first row, fifth from right) was the only African American member of the Princeton, New Jersey, Westminster Choir College during her tenure. Westminster is renowned for its outstanding choral programs and touring choirs, and Bolden was a lead soprano who sang both classical and Black spirituals. Growing up at 501 Shearman Street and receiving early education on the East Side, Bolden attended Westminster and was one of only four Black female students attending the school in the 1950s. She also sang with several choirs, including the Westminster Chapel Choir, Westminster Symphonic Choir, the New York Philharmonic Orchestra (directed by Leonard Bernstein in 1959), and the Metropolitan Choir. (Courtesy of Madeline Bolden-Johnson.)

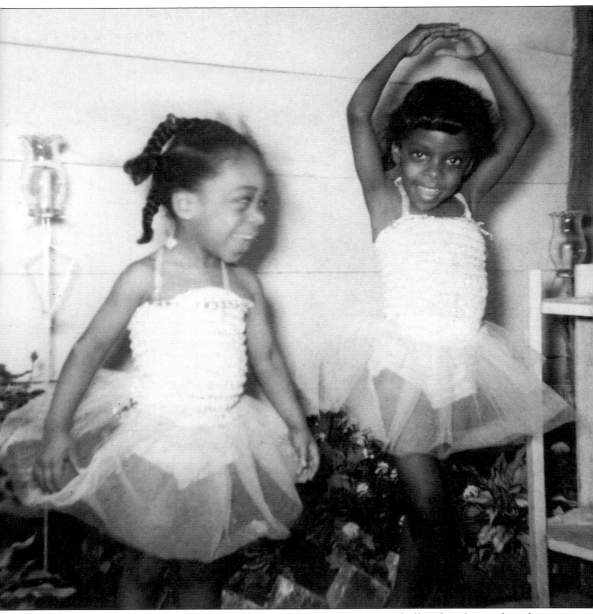

Esther (left) and Marita Lewis are dressed in their tutus practicing ballet they learned at the Walnut Street YMCA in May 1961. (Courtesy of Marita Lewis.)

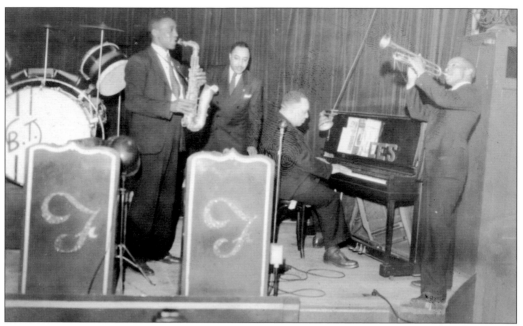

With the popularity of local bands during the early 20th century, Black artists like the ones in the Five Diamonds Band combined their talents to perform publicly. The Five Diamonds Band consisted of William "Bus" Loper Sr., Leonard Griffin, Jimmy Smith, Coleman Griffin, and Chick Lloyd. The band practiced in the restroom at Howard High School where they all attended, because the ceramic and porcelain walls provided great acoustics. Their song "Ten Commandments of Love" became an instant hit on the Treat Label in New York City during the 1950s. (Courtesy Paul and Faith Loper.)

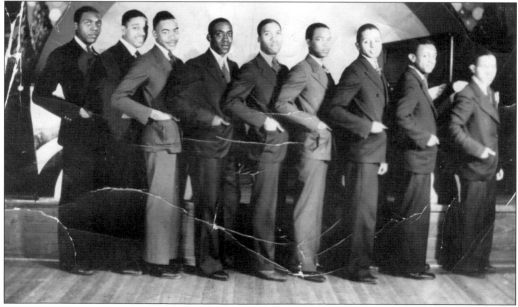

William Loper (saxophonist) and the original Five Diamonds Band occasionally played with Queen Bell and Her Noblemen Band. Loper taught instrumentation during the summer months and gave saxophone lessons to music students at Christina Community Center of Old Swedes and at People's Settlement Association. (Courtesy of Paul and Faith Loper.)

The Monday Club was established in 1876 by a group of African American men who sought opportunities for political involvement, socioeconomic freedom, and cultural enrichment in Wilmington. The all-Black male social club bought adjoining row house properties at 913–917 North French Street to provide a place where butlers, waiters, chauffeurs, and domestic workers could gather to relax, socialize, and bond. (Courtesy of Vincent Robinson.)

Pictured around the 1960s are a few members of the Monday Club. The club's membership peaked at more than 200 in the 1970s. The name referred to the only day its members had off from their service jobs. The founders were Alonzo G.B. Anderson, Burnside Anderson, Walter S. Glasgow, William H. Till, John Mason, John H. Benson, and Hirum Colder. (Courtesy of Vincent Robinson.)

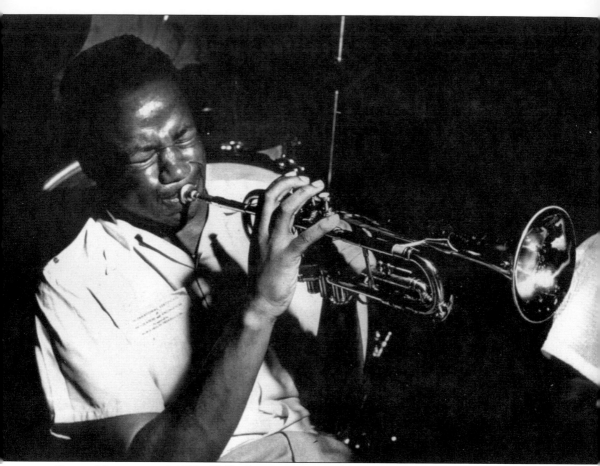

Pictured here around 1950, Clifford Brown was a celebrated jazz trumpeter noted for lyricism, clarity of sound, and grace of technique. Brown joined several bands, including Tadd Dameron's Band in Atlantic City, New Jersey; Lionel Hampton's Big Band; and the Art Blakey Quintet. He also joined with Max Roach to form the Brown-Roach Quintet. Brown died at the age of 26 in a car accident on the Pennsylvania Turnpike along with Richie Powell, the quintet's pianist. His name is memorialized on the East Side's Poplar Street where he lived, which was renamed Clifford Brown Walk. The City of Wilmington hosts the annual Clifford Brown Jazz Festival in honor of the late trumpeter and his legacy. (Courtesy of the Delaware Historical Society.)

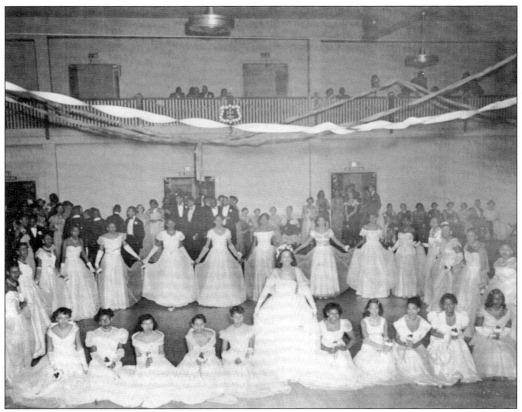

The Walnut Street YMCA provided a gathering place for countless social activities enjoyed by African American families of the East Side. Pictured is a debutante ball held at the YMCA in the 1950s. It was organized by the Omega Psi Phi fraternity. (Courtesy of Wanda Johnson, Esq.)

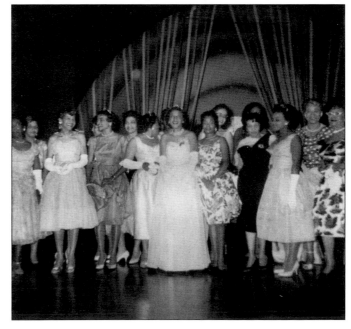

Members of the Order of the Eastern Star attend a ball at the Walnut Street YMCA in July 1961. Established in 1874, the Order of the Eastern Star is the oldest non-Greek Black women's organization in America. (Courtesy of Marita Lewis.)

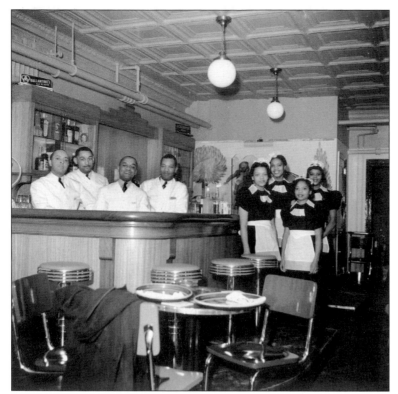

The Spot, at 1200 Walnut Street, was a social club on the East Side. Pictured are the waitstaff standing around the bar on March 20, 1940. (Courtesy of the Delaware Historical Society.)

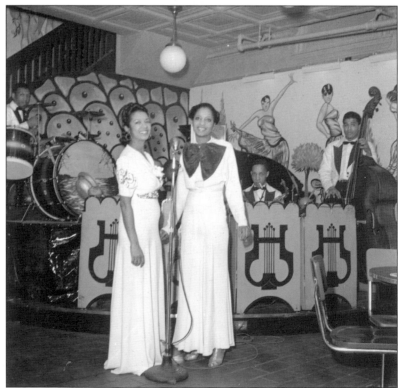

Pictured are singers with a band performing at The Spot on March 20, 1940. (Courtesy of the Delaware Historical Society.)

Pictured here are patrons sitting at tables and socializing at The Spot on March 20, 1940. (Courtesy of the Delaware Historical Society.)

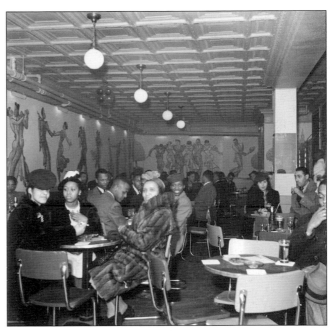

Edward Loper Jr., renowned artist, is shown around the 1960s surrounded by his paintings and working on another masterpiece. Since the early 1960s, Loper's work has been showcased at the prestigious Barnes Foundation, in numerous national exhibitions, at cultural festivals, and in publications such as *Delaware Today* magazine and the *Vistas* publication of the Barnes Foundation. His paintings are held in private and corporate collections, including the former Wilmington Trust Corporation, Blue Cross, Christiana Care, and Delaware Trust. Loper taught art, photography, and woodworking at Wilmington High School; instructed art, pottery, and sculpture at the West End Neighborhood House and Kingwood Center; and headed the visual arts department at Christiana Cultural Arts Center. (Courtesy of the Delaware Historical Society.)

This photograph shows the Market Street Wilmington Dry Goods sales floor in the late 1940s or early 1950s. Wilmington Dry Goods was a retail store where clothing and other goods were stacked in bins; it was one of the few establishments with wood floors. Many African American families in Wilmington, New Castle County, and throughout Delaware shopped for bargains here, especially the store's famous Wrangler blue jeans. (Courtesy of the Delaware Historical Society.)

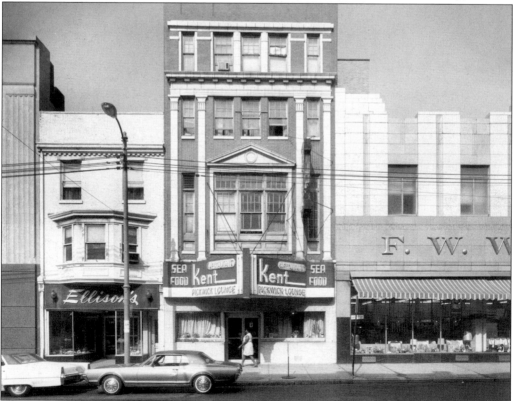

Ellison's gift shop, Kent seafood restaurant, F.W. Woolworth, and other retailers were downtown on Market Street near Wilmington's central business district around the 1960s. Woolworth was a popular shopping destination for local residents from 1947 to 1997. Some retail establishments prohibited Black people from dining and shopping in their stores during segregation in Wilmington. (Courtesy of the Delaware Historical Society.)

Six

COMMUNITY INSTITUTIONS AND URBAN RENEWAL

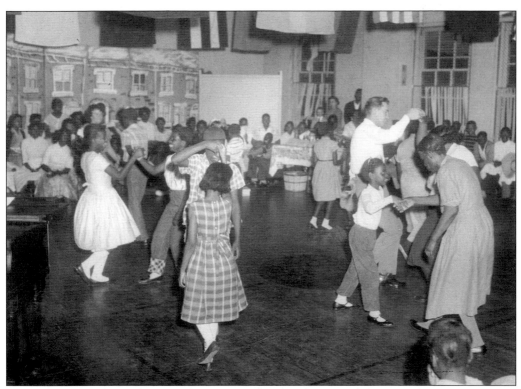

Children at the Christina Community Center of Old Swedes gathered to square dance in 1962. The center was segregated until the early 1950s, prohibiting African Americans from its programs. By 1969, the center was renamed to Christina Cultural Arts Center (CCAC) and broadened its vision to focus on preserving and celebrating African American culture in programming that teaches performing and visual arts. Today, CCAC offers professionally managed arts education for all ages centered on activities involving quality early learning to performing arts instruction, career pathways, and violence prevention programs. (Courtesy of the Christina Cultural Arts Center.)

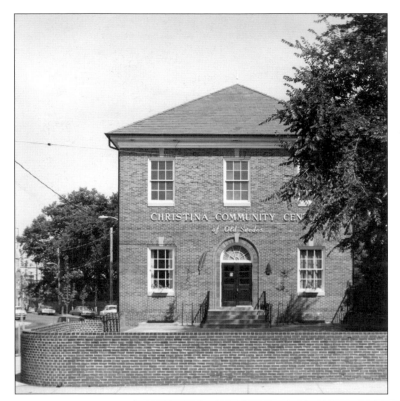

Pictured is the Christina Community Center of Old Swedes in 1964 at its original location at 800 East Seventh Street. The center was founded in 1945 by the Women's Club of Trinity Episcopal Church, originating from the settlement house movement to assist immigrants. (Courtesy of the Christina Cultural Arts Center.)

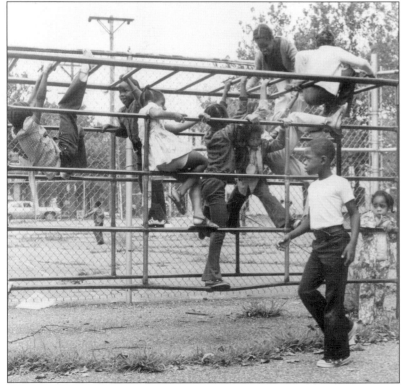

Students of Christina Community Center of Old Swedes are enjoying play time at Kirkwood Street Park in the 1960s. (Courtesy of the Christina Cultural Arts Center.)

CCAC students are participating in choir rehearsal with piano accompaniment while holding their flowers around the 1960s. (Courtesy of the Christina Cultural Arts Center.)

Pictured here is early construction of the Walnut Street YMCA building. The Y was a community center for Wilmington's African American population. Construction began on the three-story structure in 1939, and it was dedicated in September 1940. A financial gift from H. Fletcher Brown and his wife, Florence Matilda Hammett, funded both the 1939 construction and a maintenance trust fund. At the time, the facility housed both the YMCA and the Young Women's Christian Association (YWCA) and provided meeting space for organizations like the NAACP and the Human Rights League of Delaware. (Courtesy of the Delaware Historical Society.)

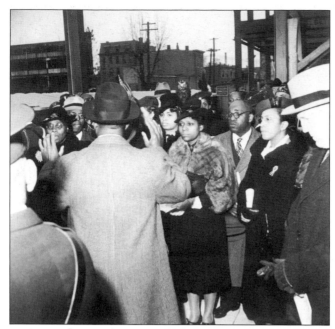

Members of the Walnut Street Christian Association are laying the cornerstone at the Walnut Street Y construction site at 1000 North Walnut Street in November 1939. The Walnut Street YMCA was listed in the 1959 *Negro Travelers' Green Book*. (Courtesy of the Delaware Historical Society.)

Thelma Young was the keynote speaker at this 1960s YWCA luncheon at the DuPont Hotel in Wilmington. Young was a founding member of the East Side's Walnut Street YWCA and a dedicated volunteer. She earned her bachelor and master degrees from Columbia University, and shortly after arriving in Wilmington in 1925, taught home economics at Howard High School. In 1952, City Councilman Edward R. Bell was general chairman of the Walnut Street YMCA and organized a 17-member executive committee to govern an annual membership campaign. He named Dr. A. Roland Milburn associate general chairman. The committee was comprised of Dr. Leon Anderson, J. Ernest Barkley, G. Oscar Carrington, Dr. Wayman Coston, S. Chester DeShields, William Emory, John O. Hopkins Sr., John O. Hopkins Jr., Adam Johns, Rev. J.L. Morgan, Philip Sadler, Dr. O.N. Smith, Rev. O.H. Spence, Eldridge J. Waters, Fletcher White, Edward Wilson, and Rev. Donald O. Wilson. (Courtesy of the Delaware Historical Society.)

In 1998, the original YMCA was demolished and a new structure built in its place. The tower and relief friezes depicting Marian Anderson, Booker T. Washington, and Dr. George Washington Carver are the only original 1939 elements used in the new building. The finished site featured an auditorium, pool, fully equipped gymnasium, bowling alleys, library, and a billiard room. (Author's collection.)

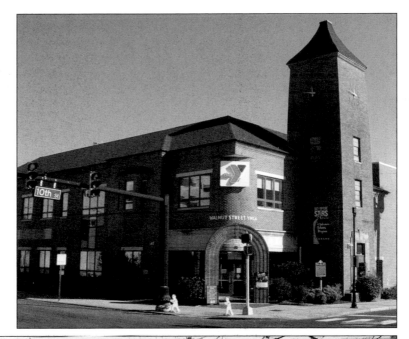

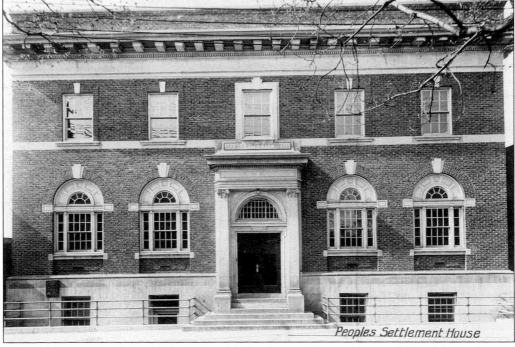

Pictured here around the 1940s is People's Settlement House (renamed People's Settlement Association) at 408 East Eighth Street. Founded by Sarah Webb Pyle in 1901 to address the needs of the European immigrants settling in Wilmington, People's Settlement House in later years became known for a tradition of caring and as a safe haven for African American families who migrated to Wilmington and settled in segregated neighborhoods on the East Side. Today, People's Settlement continues to provide services to improve the quality of life for residents of the East Side and Wilmington. (Courtesy Delaware Historical Society and People's Settlement Association.)

James Sills Sr. (left) was executive director of the People's Settlement Association from 1963 to 1970. Sills is pictured here in 1969 with Mayor Harry G. Haskell Jr. and children, from left to right, Julie Sills, Lisa Blunt, Marla Blunt, and Thea Blunt. Sills and his family were residents of the East Side from 1962 to 1998. He served a distinguished career in government, education, and civic leadership on the East Side and in Delaware. Sills was the first Black city councilman (at large) and Wilmington's first Black mayor, serving two terms from 1992 to 2001. (Courtesy of Ted Blunt.)

A lifeguard oversees swimmers at Kruse Pool in 1939. The pool, which was on the roof of the building at 1325 Poplar Street, was named after Edwina B. Kruse (February 1848–June 1930), a Delaware educator born in Puerto Rico who lived on the East Side at 206 East Tenth Street. Kruse was principal of Howard High School for nearly 40 years. (Courtesy of the Delaware Historical Society.)

Pictured are three lifeguards at Kruse Pool on August 3, 1939. Edwina B. Kruse believed that Black students in Delaware deserved the highest quality of academic excellence possible. Kruse followed through on her dream to establish the Sarah Ann White Home for the Elderly at 822 French Street, another community-serving facility that consolidated with the Layton Home for Colored People in 1915. Lincoln University conferred an honorary degree on Edwina Kruse in 1947—the first presented to a woman. (Courtesy of the Delaware Historical Society.)

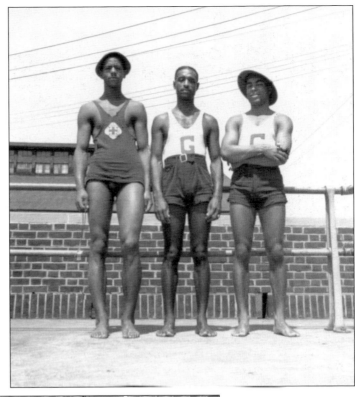

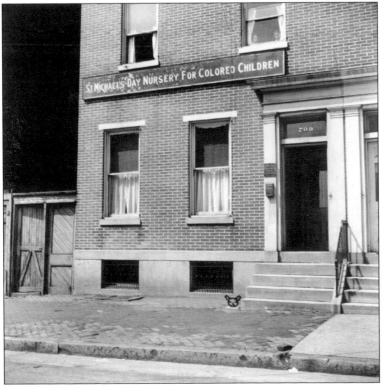

Pictured is St. Michael's Day Nursery for Colored Children at 709 French Street in the early 1900s. By the early 1940s, the nursery expanded its services to provide kindergarten and extended after-school services for African American children. Urban renewal along French Street in the 1960s forced the nursery to relocate to 305 East Seventh Street, which became its home for more than 50 years. (Courtesy of the Delaware Historical Society.)

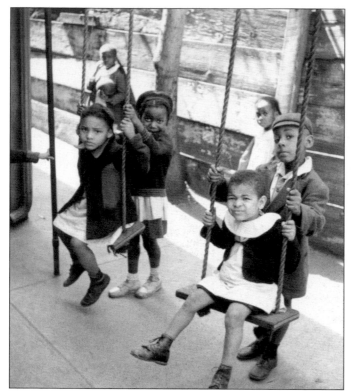

Parents who dropped off their children at the nursery typically arrived at 7:00 a.m. The children remained under the care of director Lennie Lewis and her staff until approximately 5:30 p.m., Monday through Friday. Youngsters would get three substantial, well-balanced meals each day. Outdoor activities and rest periods were well supervised. During this time, staff recalled that the automatic washing machine ran continuously, and each child would greet his or her parents at the end of the day as clean as possible. (Courtesy of the Delaware Historical Society.)

Children listen to stories read by a teacher at St. Michael's Day Nursery for Colored Children around the 1940s. St. Michael's was established by Rev. A.I. Dupont Coleman, vicar of St. Michael's Mission in 1889, to care for children of color whose parents worked in a nearby factory. It was the oldest day care facility in the state at the time. Over a century, the nursery grew and adapted to the changing and often unmet needs of the community. (Courtesy of Lucinda Ross and the St. Michael's School and Nursery.)

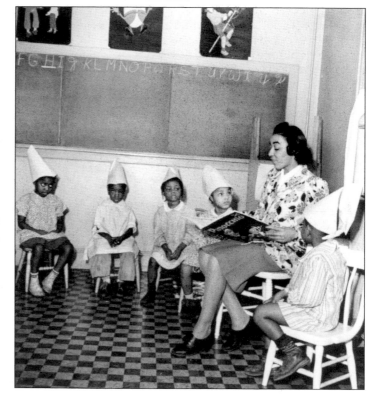

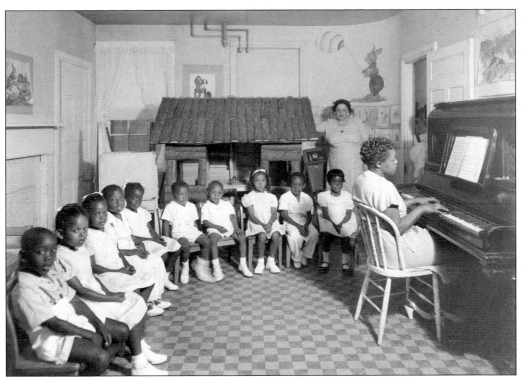

Pictured are teachers with children during music class in the 1940s. The nursery provided a safe haven for adopted children, including overnight care for homeless children, a hospital for the treatment of Black babies, and childcare for mothers who worked in local tanneries. Today, St. Michael's School and Nursery remains committed to the East Side community and was recognized as a Delaware historic landmark that welcomes all children from diverse backgrounds at all income levels. (Courtesy of Lucinda Ross and the St. Michael's School and Nursery.)

Lennie Lewis is shown reading to daughters Marita (left) and Esther in the 1950s. Lewis served as facility director at St. Michael's for 25 years. In recognition for her lifelong commitment to serving the needs of children, a St. Michael's scholarship was named in her honor upon her retirement. (Courtesy of Marita Lewis.)

This September 1959 photograph shows the demolition of houses between Walnut and Lombard Streets on Wilmington's East Side. (Courtesy of Marita Lewis.)

Pictured is an aerial view of the impact of urban renewal, designated as slum clearance, on the East Side of Wilmington from center city looking south to Interstate 95. (Courtesy of the Delaware Historical Society.)

C O P Y C O P Y

September 23, 1964

St. Michael's Day Nursery Re: Civic Center Urban
Nursery & Hospital Renewal Project
709 French Street
Wilmington, Delaware

Dear Sirs:

As you no doubt know the property at 709 French St., which according to our records is owned by you, is in the Civic Center Urban Renewal Area.

At the request of the Chairman of the Wilmington Housing Authority, Mr. Joseph D. DiSabatino, we are sending this letter to request you to contact the writer at 905 Washington Street, or telephone OL 5-5522, before making any improvements or alterations to your property mentioned above. Also, please be sure you are dealing with an authorized representative of this Authority when discussing the sale of the property owned by you.

We are now in a position to start negotiations, and if you are ready to sell please send a letter to the Authority requesting a personal contact by our representative.

 Sincerely,

 SLUM CLEARANCE & REDEVELOPMENT AGENCY
 WILMINGTON HOUSING AUTHORITY

 Dudley T. Finch
 Executive Director

DTF:mlb

This September 23, 1964, letter from the Wilmington Housing Authority informed officials at St. Michael's Day Nursery for Colored Children on their position to negotiate acquisition of property owned by the nursery as part of the civic center urban renewal project. While the civic urban renewal project was designed to eliminate slum clearance and improve residential and commercial properties, some longtime residents of the East Side claimed that the planned improvements also resulted in a breakdown of the existing social and economic fabric of their community. (Courtesy of Marita Lewis.)

DISCOVER THOUSANDS OF LOCAL HISTORY BOOKS
FEATURING MILLIONS OF VINTAGE IMAGES

Arcadia Publishing, the leading local history publisher in the United States, is committed to making history accessible and meaningful through publishing books that celebrate and preserve the heritage of America's people and places.

Find more books like this at
www.arcadiapublishing.com

Search for your hometown history, your old stomping grounds, and even your favorite sports team.

Consistent with our mission to preserve history on a local level, this book was printed in South Carolina on American-made paper and manufactured entirely in the United States. Products carrying the accredited Forest Stewardship Council (FSC) label are printed on 100 percent FSC-certified paper.

MADE IN THE